JOSEPH A. ROSEN

BLUES
HANDS

PHOTOGRAPHS OF THE HANDS OF BLUES MUSICIANS AND MORE

Schiffer Publishing Ltd

4880 Lower Valley Road • Atglen, PA 19310

The Blues is the roots, everything else is the fruits.

−Willie Dixon

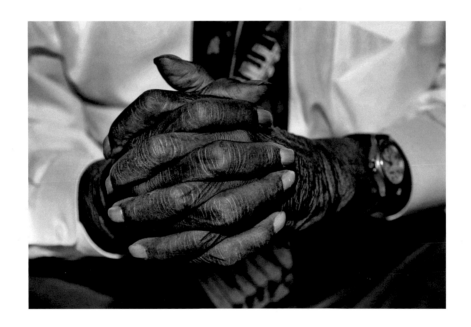

A portion of any funds realized from this book will be distributed to the Blues Foundation HART Fund, the New Orleans Musicians Clinic, and the Doc Pomus Financial Assistance Program of the Rhythm & Blues Foundation.

Other Schiffer Books on Related Subjects:

Early Years of Rhythm and Blues, ISBN: 978-0-7643-1983-9
Musical Ink, ISBN: 978-0-7643-4443-5

Designed by JOHN P. CHEEK
Cover design by MATT GOODMAN
Type set in Futura Std

ISBN: 978-0-7643-4963-8
Printed in China

Published by Schiffer Publishing, Ltd.
4880 Lower Valley Road
Atglen, PA 19310
Phone: (610) 593-1777; Fax: (610) 593-2002
E-mail: Info@schifferbooks.com

For our complete selection of fine books on this and related subjects, please visit our website at www.schifferbooks.com. You may also write for a free catalog.

This book may be purchased from the publisher. Please try your bookstore first.

We are always looking for people to write books on new and related subjects. If you have an idea for a book, please contact us at proposals@schifferbooks.com.

Schiffer Publishing's titles are available at special discounts for bulk purchases for sales promotions or premiums. Special editions, including personalized covers, corporate imprints, and excerpts can be created in large quantities for special needs. For more information, contact the publisher.

To my parents, Jeanette and Bernard Rosen. They gave me the confidence and support to follow a difficult but rewarding career and life path. I think of and miss them every day.

CONTENTS

AUTHOR STATEMENT

First, I'm a fan of Blues music. I also happen to be a professional photographer. This combination has led to a thirty-plus year adventure photographing the Blues. I've shot everywhere from rough juke joints to elegant concert halls and luxury liners. *Blues Hands* is one part of that adventure.

Like most photographers of musicians, I would occasionally shoot their hands. While I was editing one day, a photo of Jimmy McCracklin's bejeweled hand and another of the hand, bass guitar, and cigarette of Cliff Belcher both "jumped out" at me.

I knew then that I had a theme and a thread that I would follow: hands tell a story.

I hope you enjoy the photographs—some created for this project and others I had from the past. And always, above all, enjoy the music.

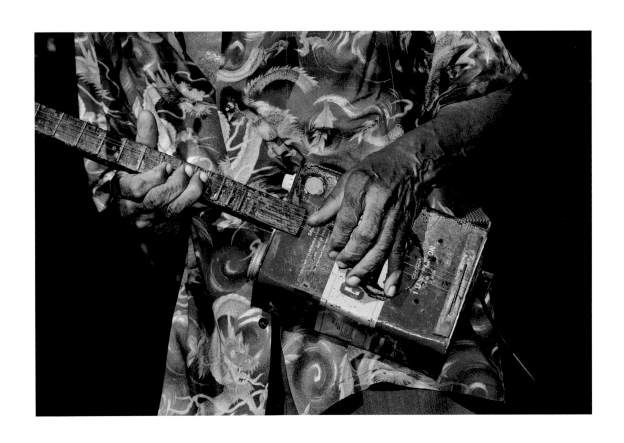

SHOOTER AND PHOTOGRAPHER

First of all, let's understand the difference between a "shooter" and a "photographer." The first one wants you to see all 250 images he shot in a club last night. While there is some measure of appreciation for the shooter who is determined to make a visual record of everything that happened, the photographer does not show that many photos from a three-day music festival with multiple artists on two stages.

On the level of professional photographers, we all use essentially the same equipment. Not much difference in camera bodies or lenses. But what sets the good ones apart from the herd is the sense of what separates a genuine "keeper" from the ordinary.

Joe Rosen knows how to set up a photograph and then close the deal at just the right instant. Neither of these qualities can be bought or downloaded. It takes experience, true, but primarily, it is an innate creativity to see the unseen, to move beyond the obvious and bring forth an image that is brilliant today and timeless for the memory.

Dick Waterman is a photographer, author, member of the Blues Foundation Hall of Fame, and former manager for Son House, John Hurt, Buddy Guy, Bonnie Raitt, and other Blues artists.

SOUL THROUGH HANDS

Years ago, I learned that certain cultures would not allow people to take their portraits, as they believed that their souls would be captured forever in the photos. I always thought yes, that is what a good photographer should reveal, and Joe always has. His pictures of musicians over the years have captured their spirit, whether taken of them performing or just hanging out.

This collection of images finds a way to bring to light the musicians' souls through their hands. Looking at photos of performers making music, I often find myself paying attention to the background, the crowd, and the other players on stage, which gives me a more complete picture of the scene and the times. Joe's focus on the artists' tools—their hands—adds to that mosaic.

Make no mistake: these are powerful fingers and grips. That the photos also show us some of the quintessence of the artists makes them quite remarkable

Bill Wax is an original Program Director of BB King's Bluesville on Sirius XM Radio and former Chairman of the Board of Directors, Blues Foundation.

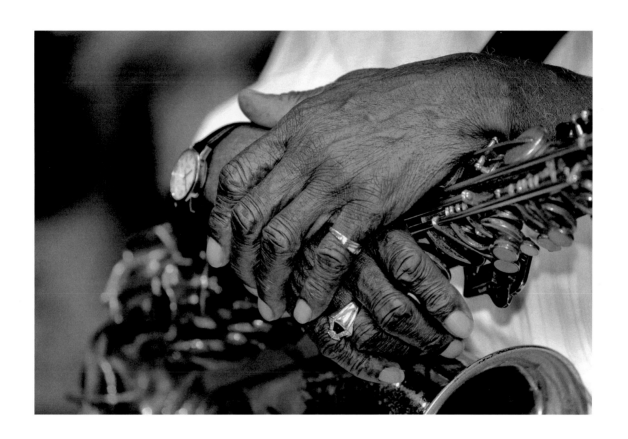

INTRODUCTION

Before information reaches the hands in Joe Rosen's remarkable photographs it must travel through the mind, the heart, and the soul. While heart and mind contribute mightily to any performance, it is the soul that is the final arbiter of the end result.

The soul of a bluesman tells us about his feelings, and it is those feelings that get transmitted to the hands—and ultimately to the listener. Feelings rarely stay the same day after day. One day they may express great joy, another day great sorrow. And of course there are gradations of each emotion.

On occasion, Bluesmen are required to express great joy when they personally feel great sorrow. To be able to do this convincingly is what separates the master from the amateur. The professional musician knows how to do this, but it is never easy. The Blues may be simple in form, but not in execution. The Blues is never easy.

Most often traditional Blues were concerned with money, whiskey, or mobility. A more modern take on the music might find subject matter relating to casinos, cocaine, or cell phones and other related facets of digital technology. But regardless of the era, the essence of the Blues still revolves around the relationship between a man and a woman.

The ground rules of such relationships have changed considerably. Violence in either direction is often recounted in Blues lyrics. Such behavior—easily condoned and often overlooked at one time—would quickly land one in jail today. Yet love, or the lack of it, is a constant theme of the Blues. The longing for an absent mate can be a momentary annoyance or a life-changing albatross.

And love has become more complicated as well. Doubtless there are still "backdoor men" and "midnight creepers," and just as certainly there is the "million dollar secret." But sooner or later someone will write a Blues lyric about no-fault divorce or prenuptial agreements. The more things change, the more they stay the same.

In viewing the hands in this book, one is aware of great differences: youthful or venerable; lots of rings or no rings; or short stubby digits or long slender fingers, all being utilized in the service of music. And what music is being played? In viewing James Brown or Mavis Staples, one can instinctively conceive the nature of the performance, but what of the guitarists?

We can see string-benders, slide mavens, and chord manipulators at work, and while we can't hear them, we can certainly let our imagination run wild as to exactly what is being played. The instruments utilized can be similar, but just as each pair of hands is unique so is the music those hands produce.

But another body part is required to complete this process. Without the trained eye of the photographer, you would have snapshots rather than the remarkable art available on these pages. Joe Rosen has been trailing the performers showcased in this work for many years. *Blues Hands* is his gift to all of us, whether present at those events or not.

Thanks, Joe.

Bob Porter is a Grammy Award-winning writer/producer, radio personality on WBGO/Newark, and a member of the Blues Foundation Hall of Fame.

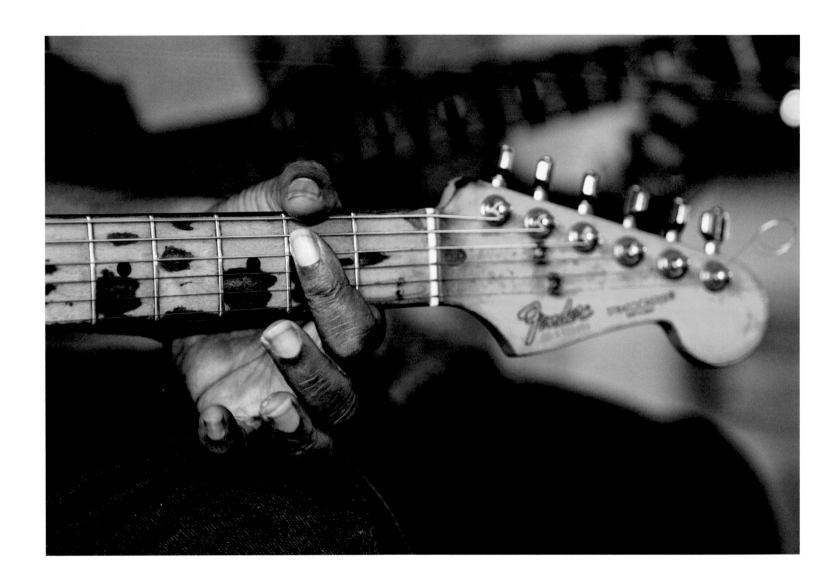

TROMBONE SHORTY

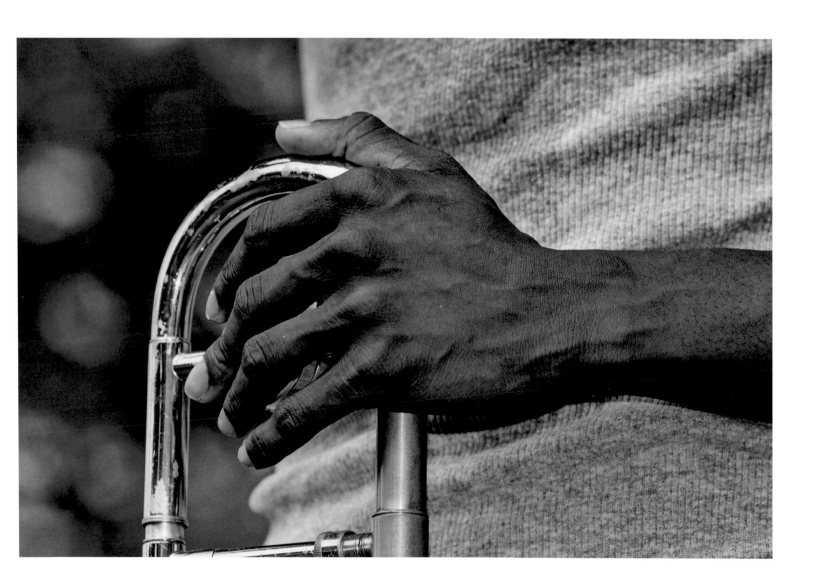

JOHNNY WINTER

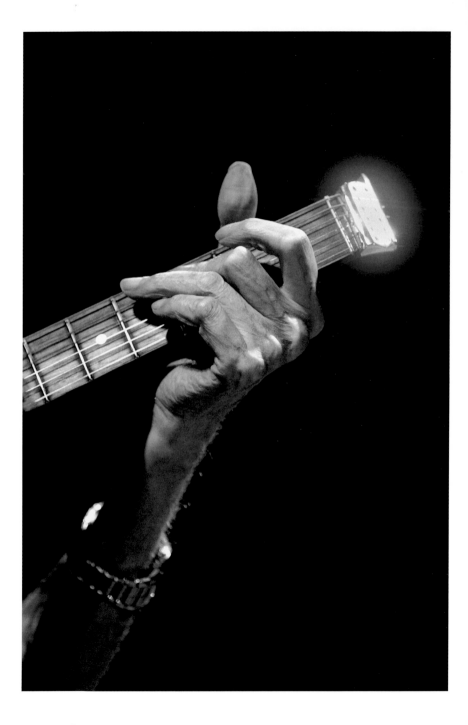

SUPER CHIKAN JOHNSON

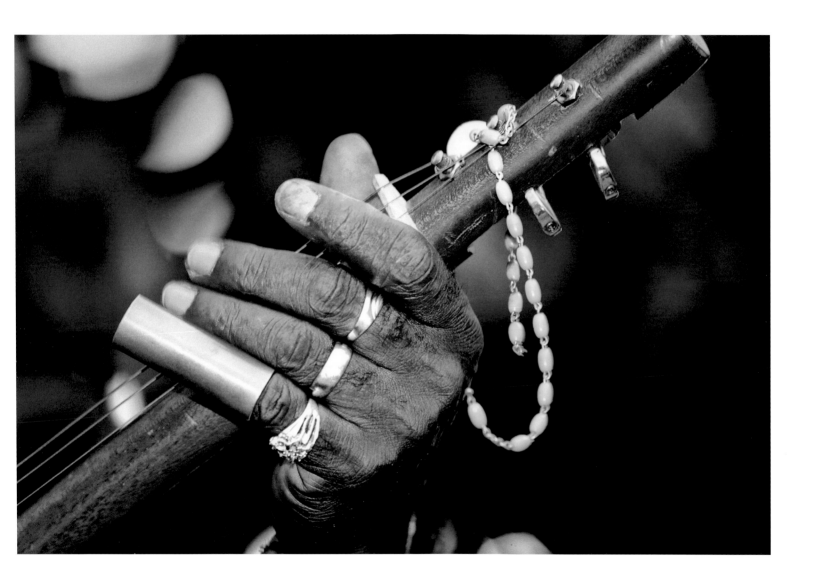

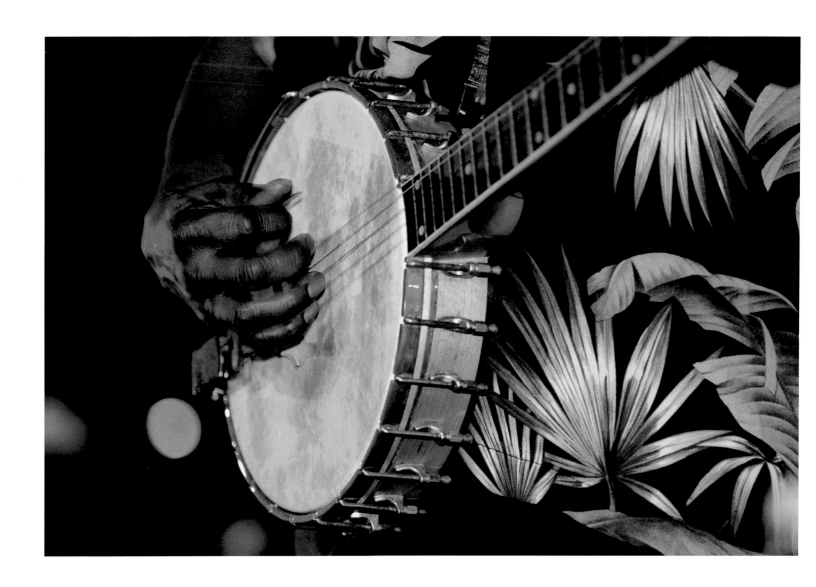

SMOKIN' JOE KUBEK

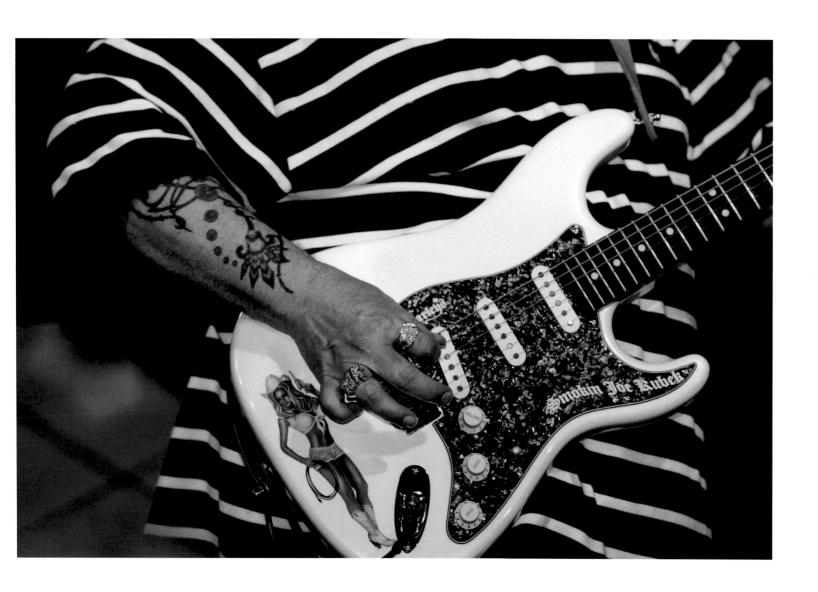

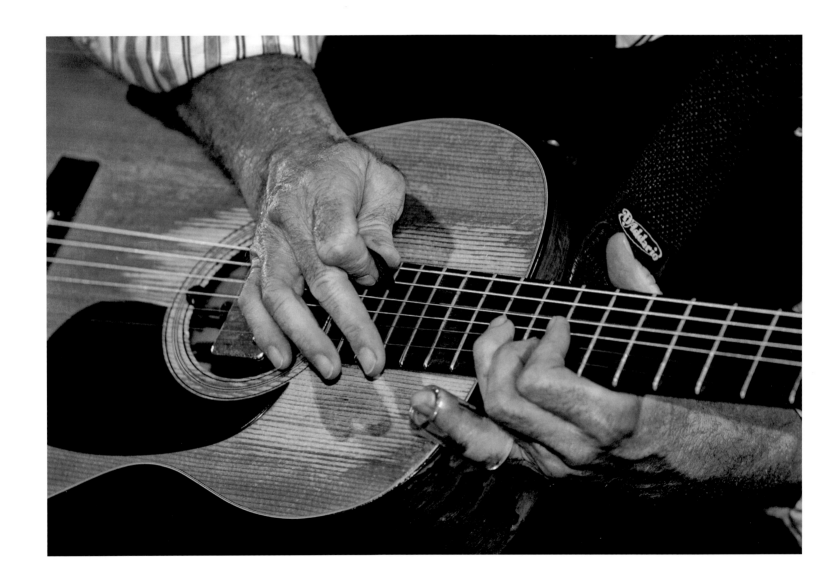

MAVIS STAPLES

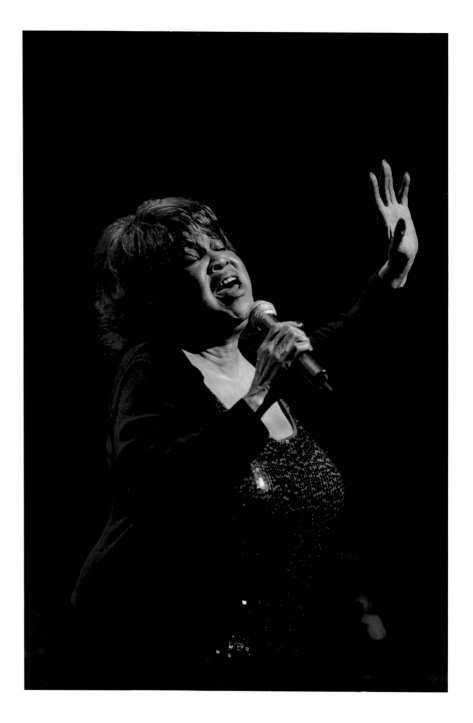

LES PAUL

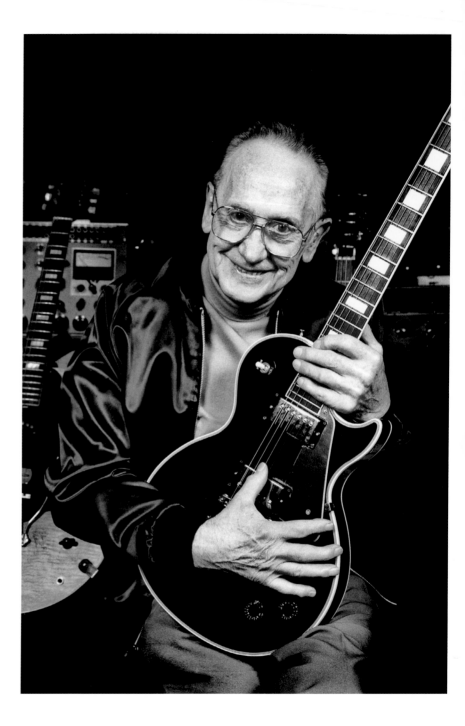

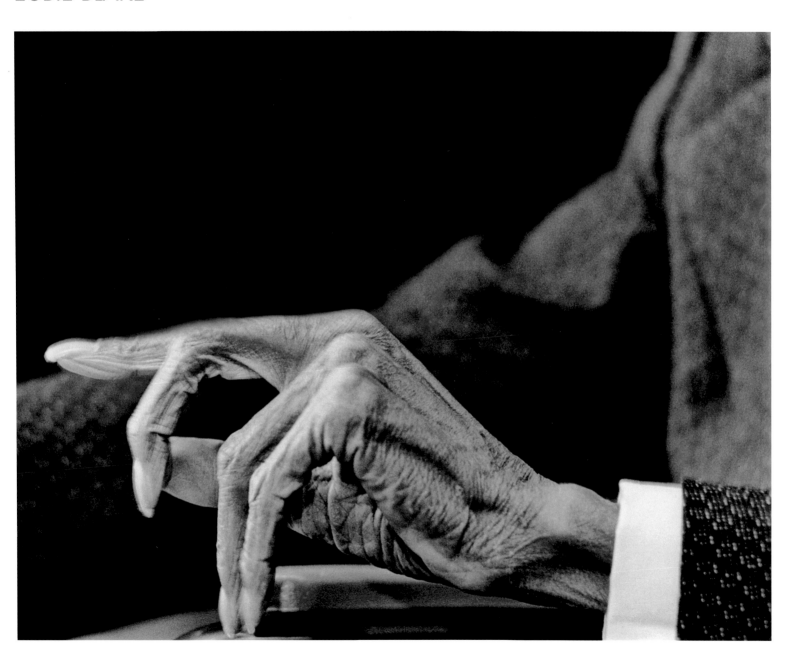

LC ULMER

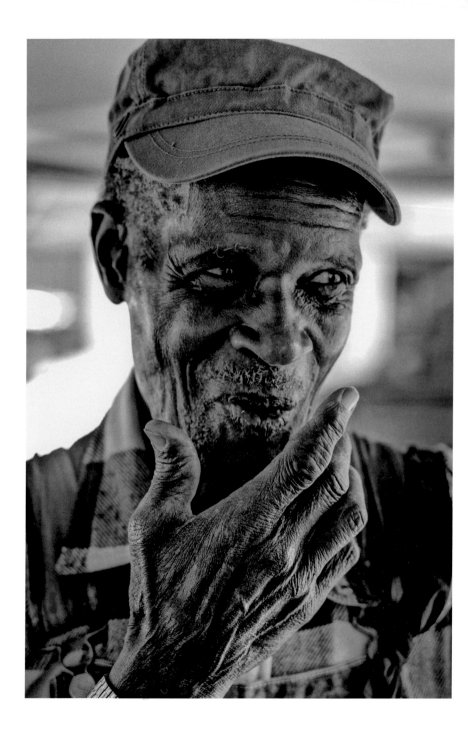

FRANK CHRISTIAN

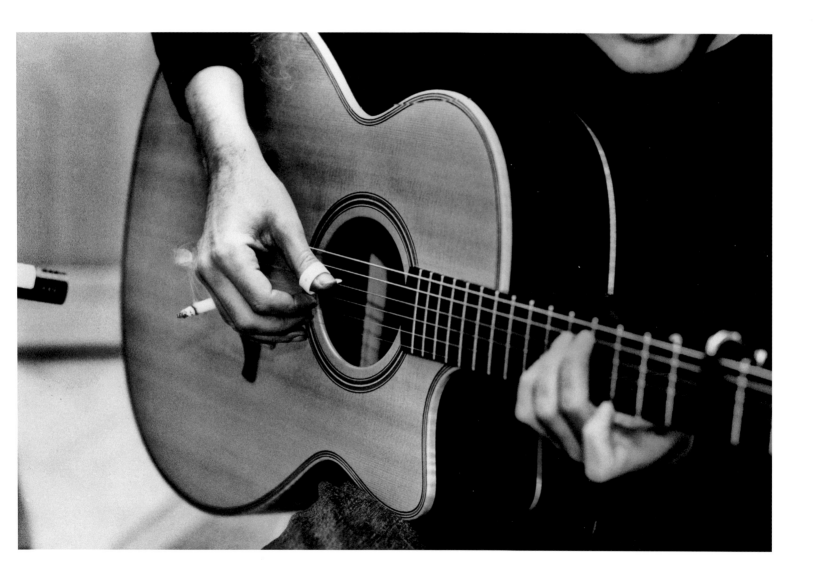

SHAKURA S'AIDA

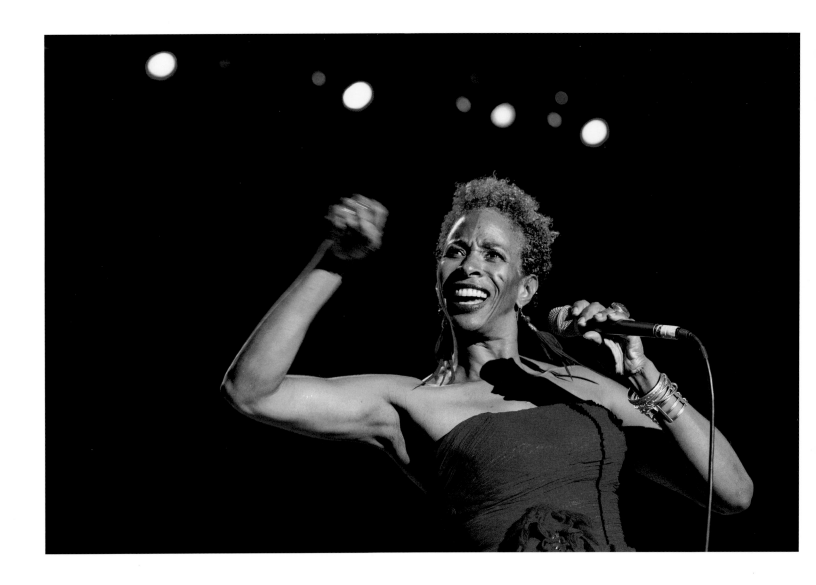

IRMA THOMAS

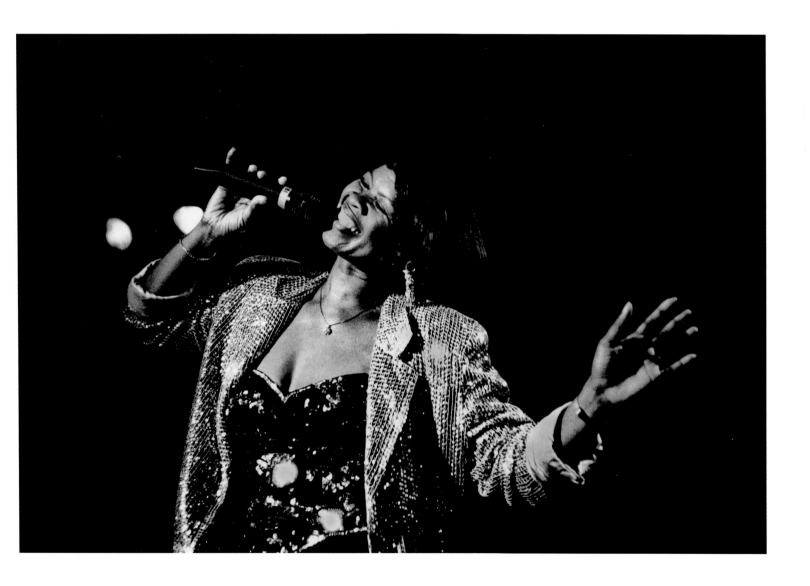

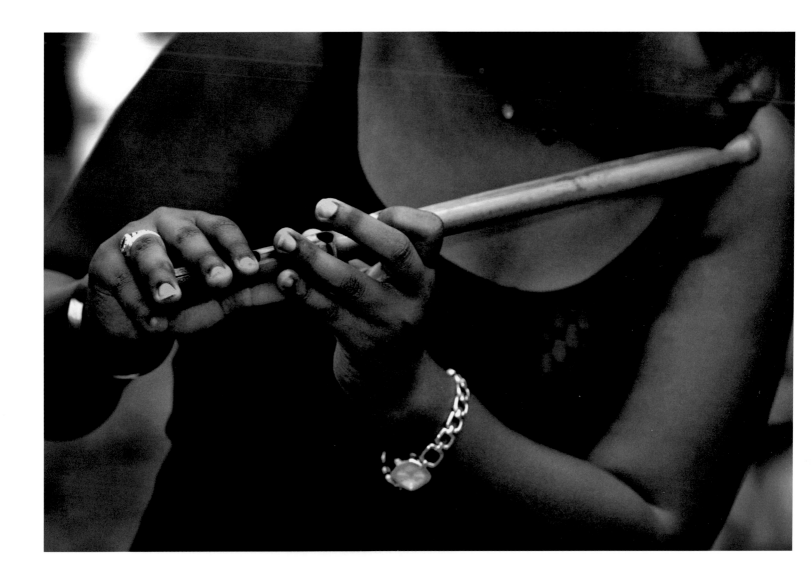

HARRISON KENNEDY

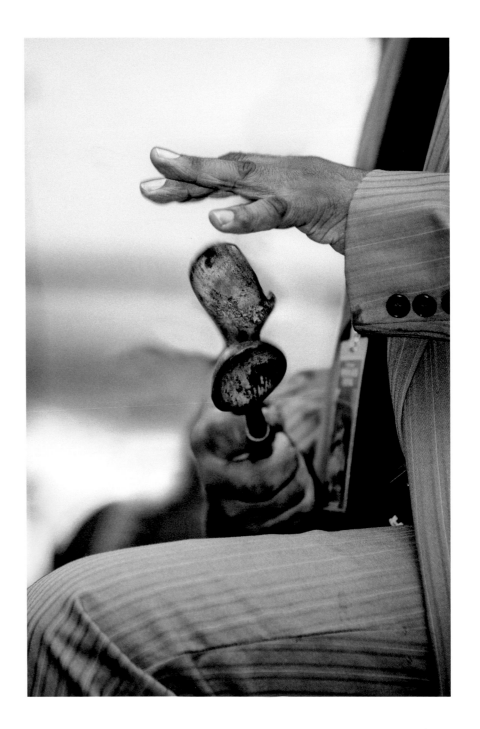

LOUISIANA RED

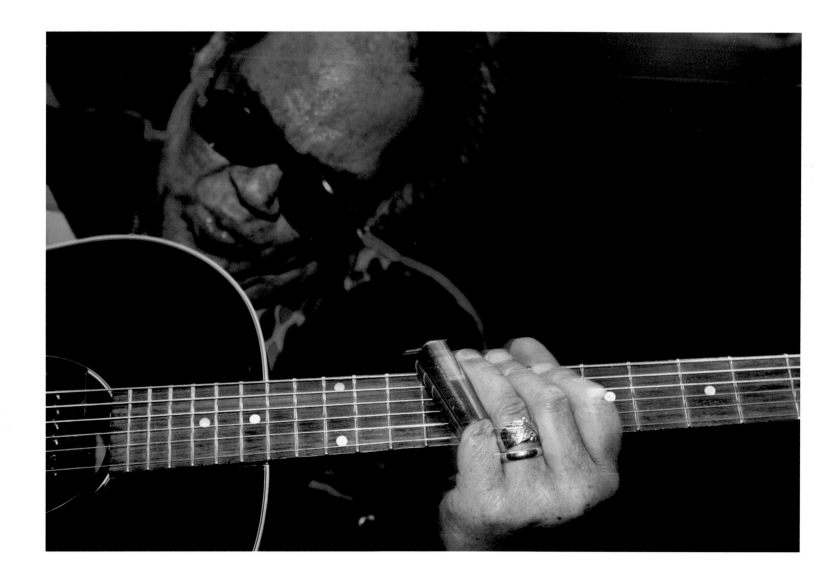

B.B. KING

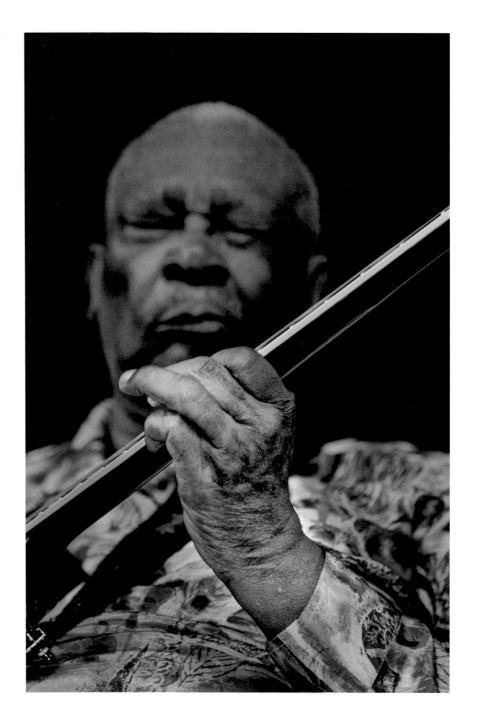

AL GREEN

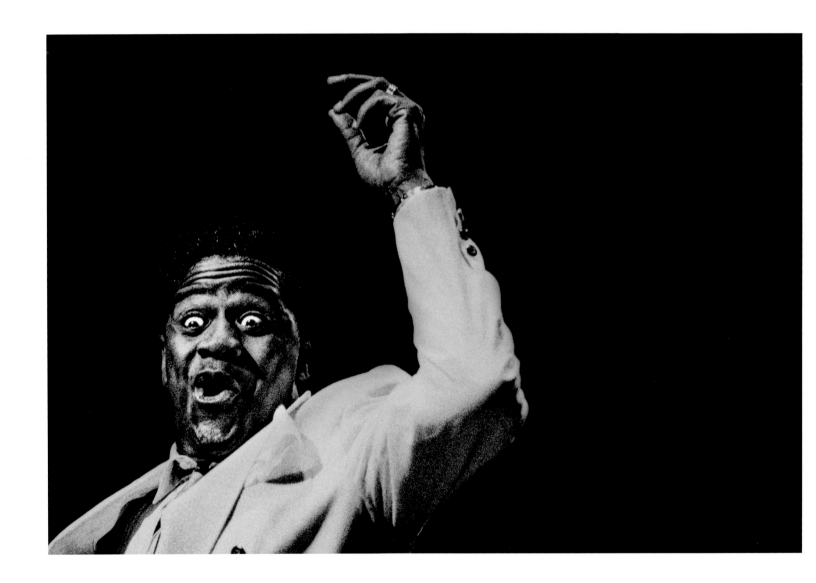

JAMES BROWN

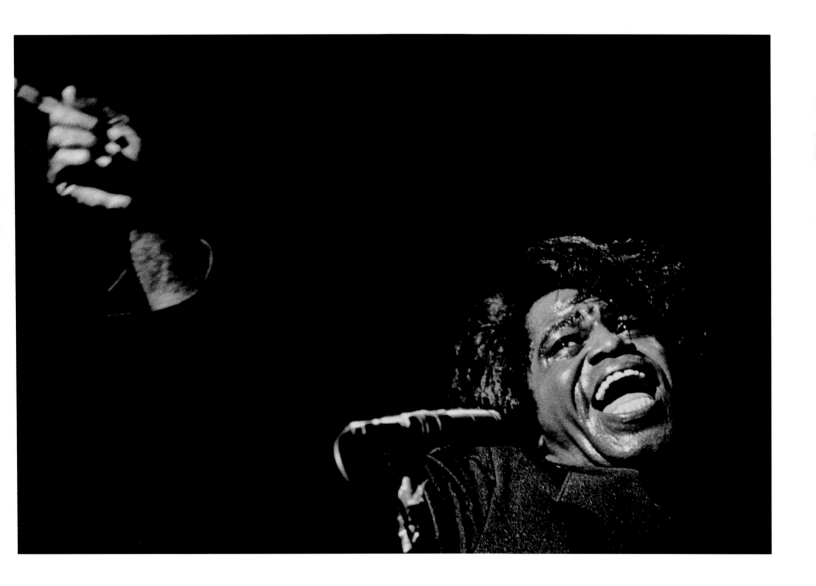

CHUCK JACKSON

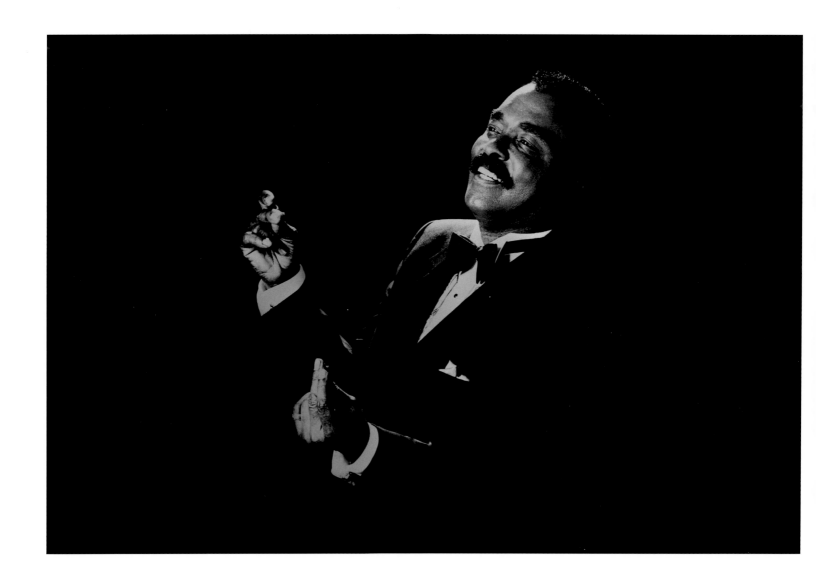

MAXINE BROWN

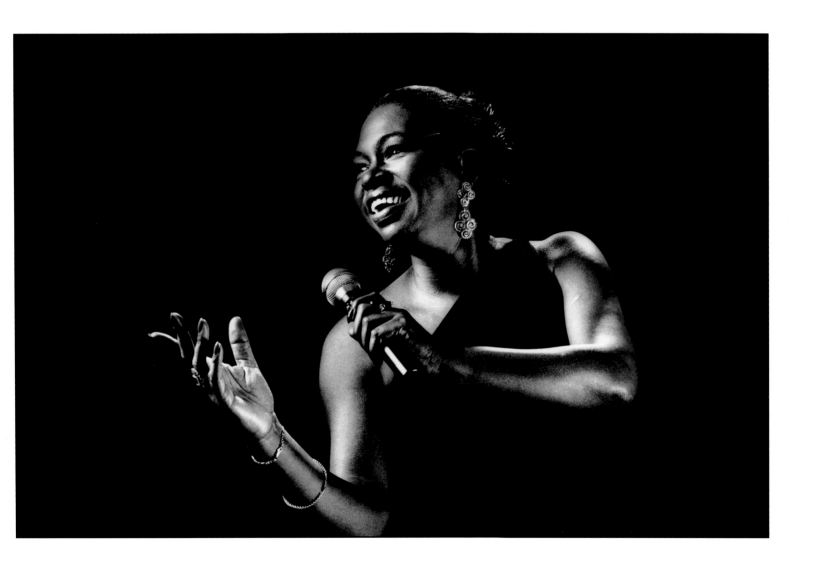

KIM WILSON

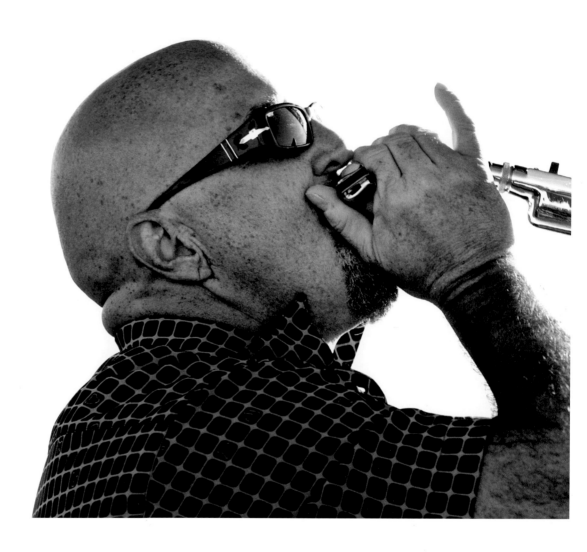

CHARLIE MUSSELWHITE

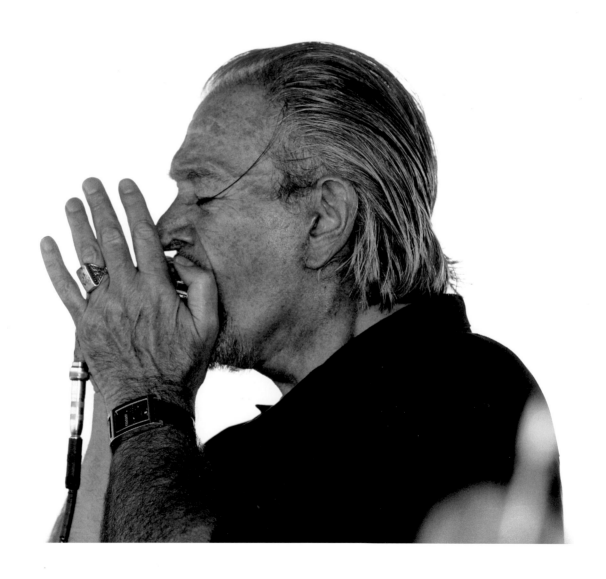

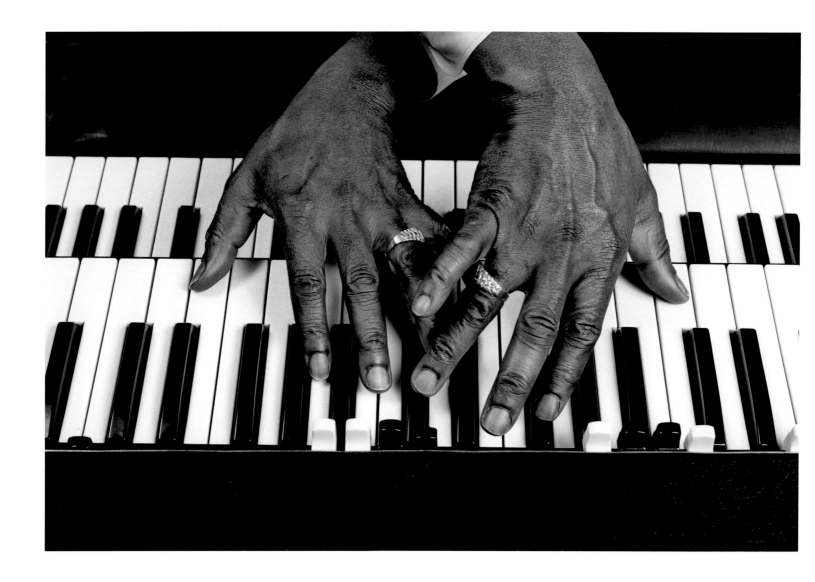

JELLYBEAN JOHNSON

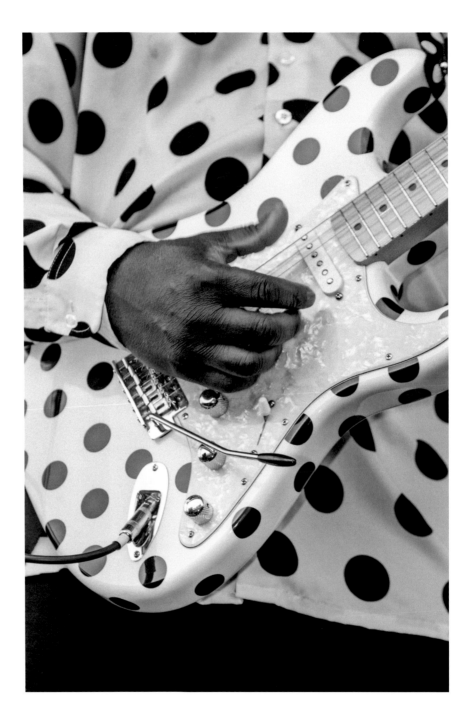

JOE LOUIS WALKER

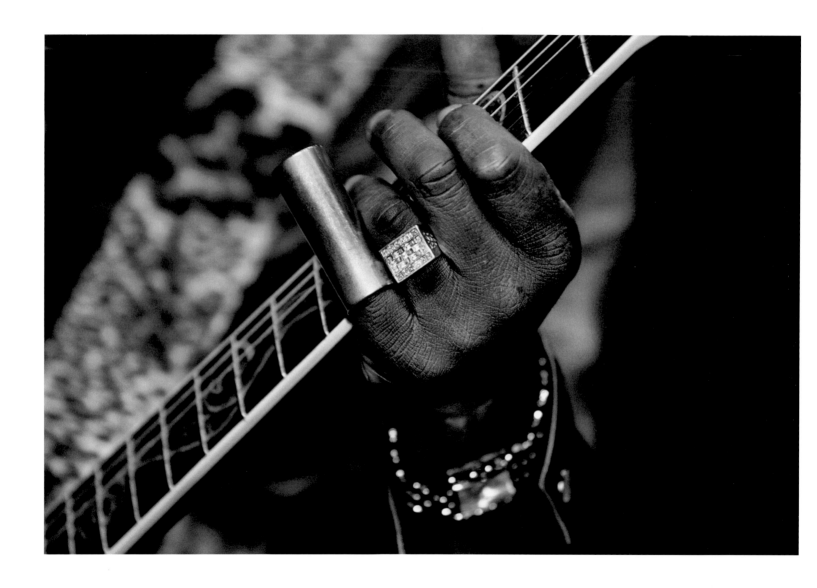

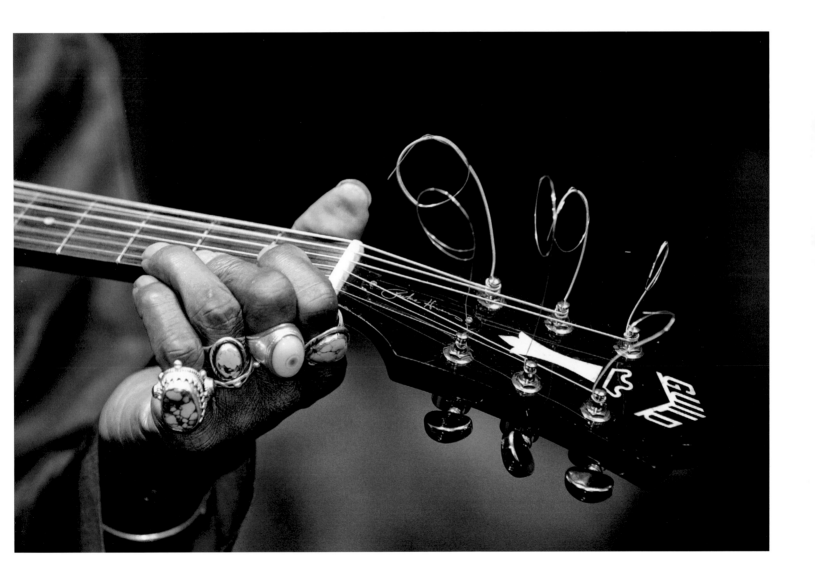

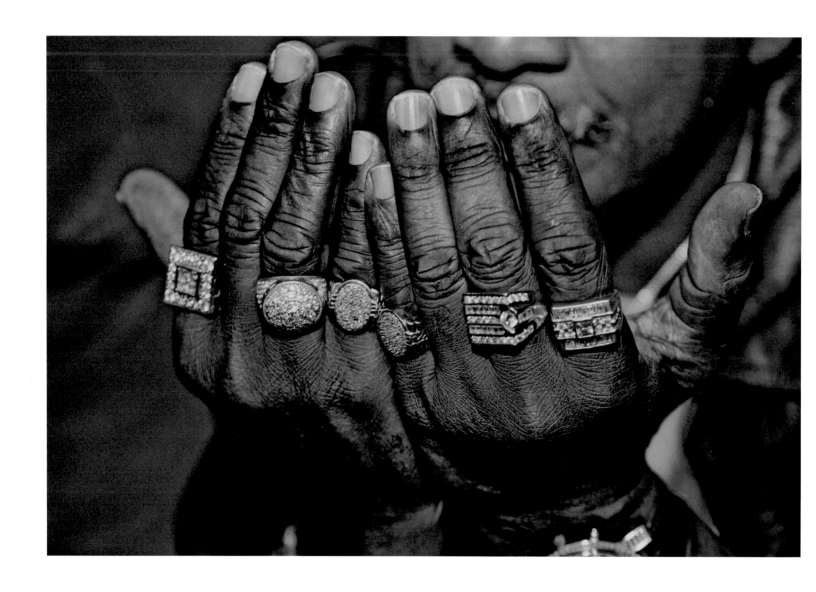

1033

EDDIE DANIELS

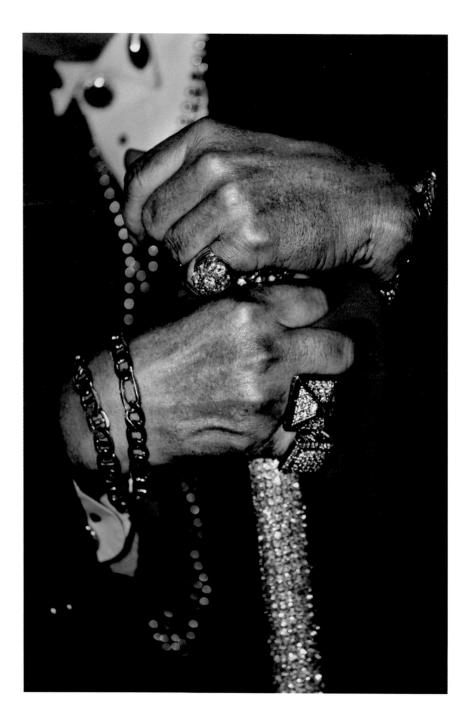

GARY CLARK JR.

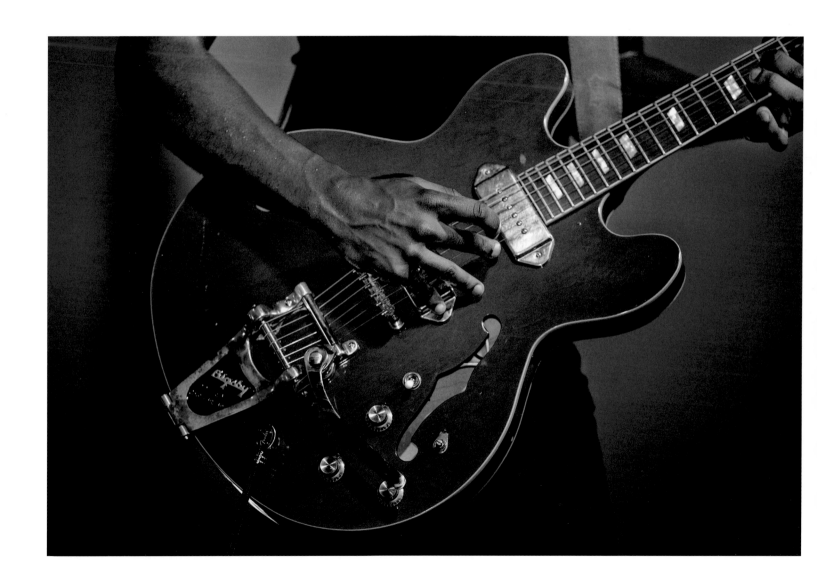

LIL' ED WILLIAMS

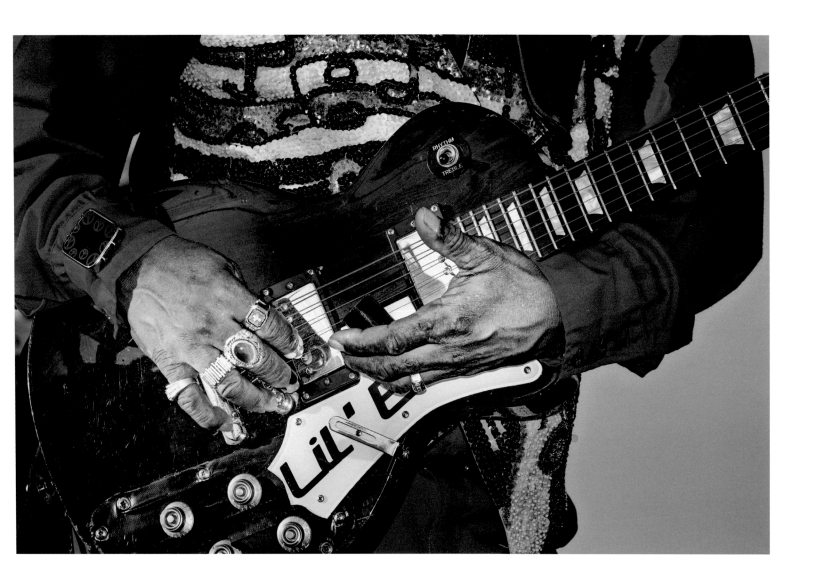

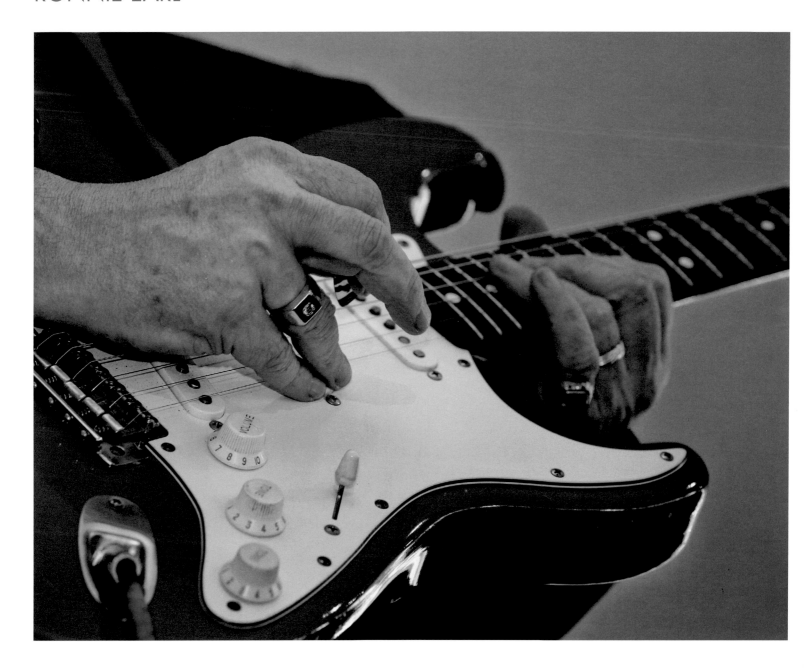

SHEMEKIA COPELAND

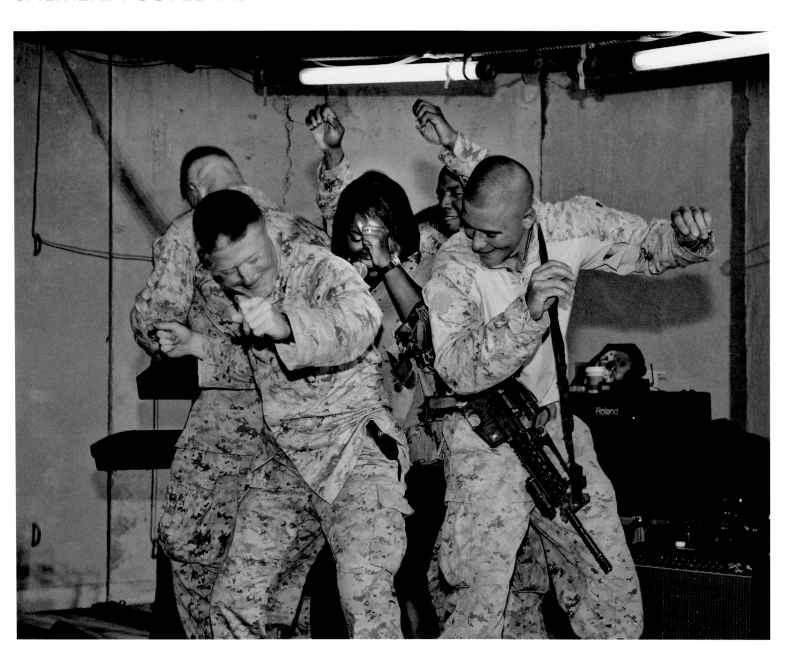

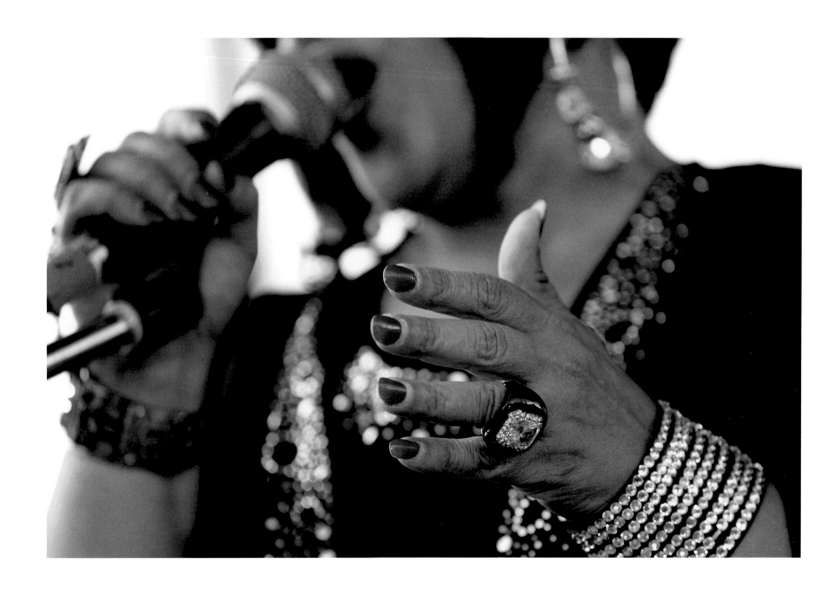

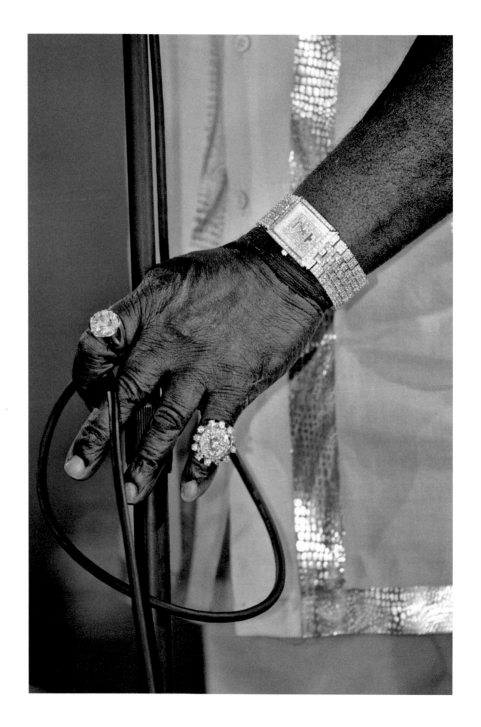

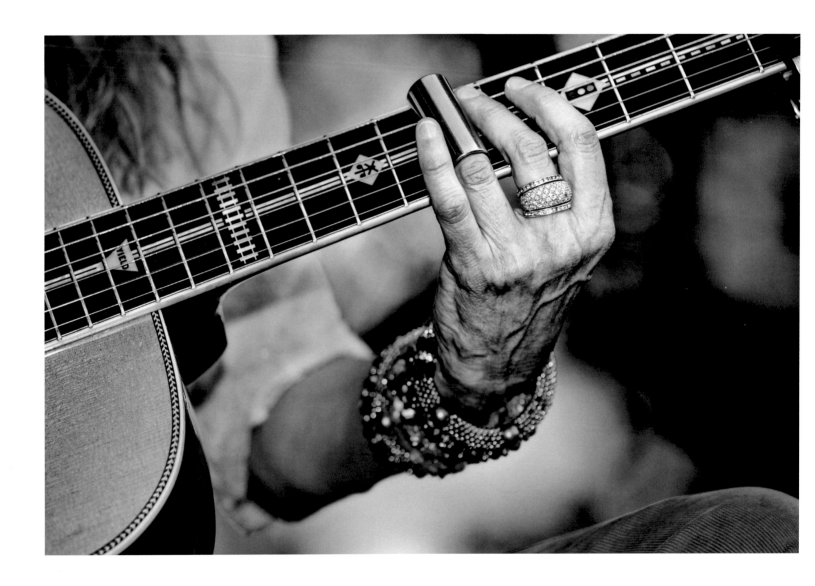

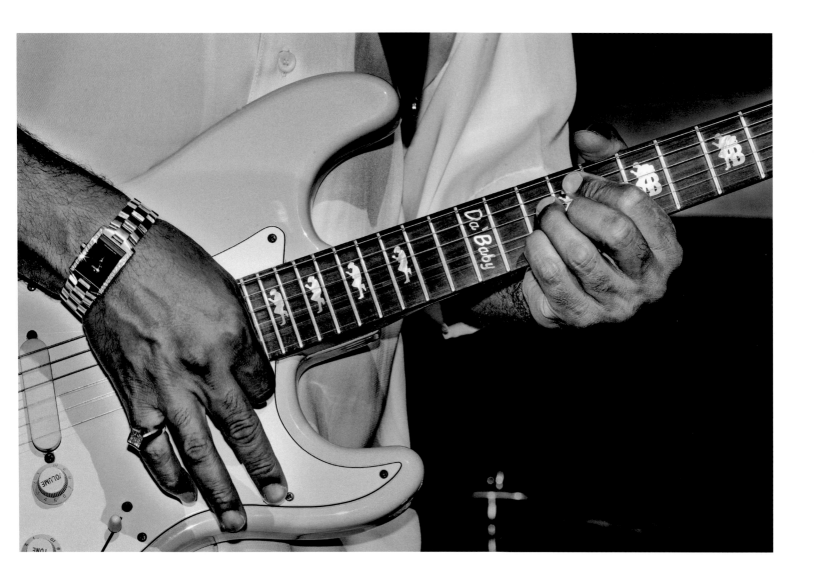

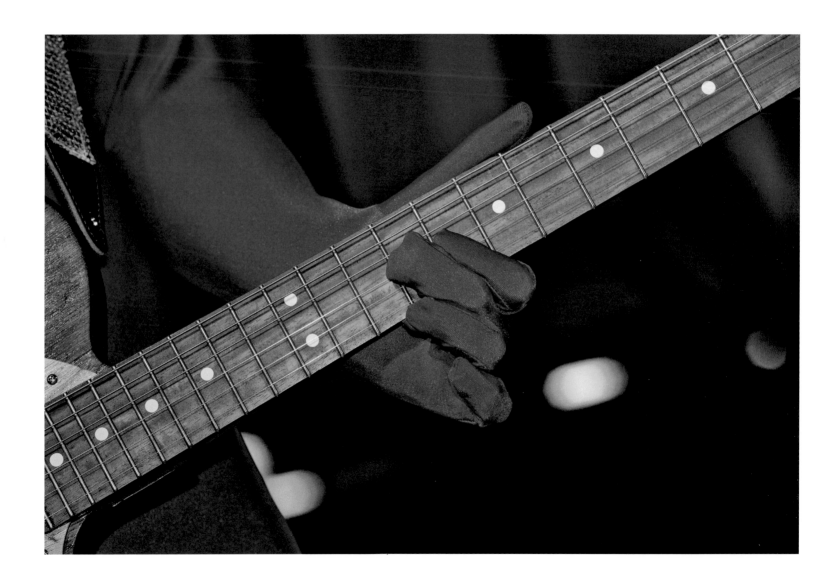

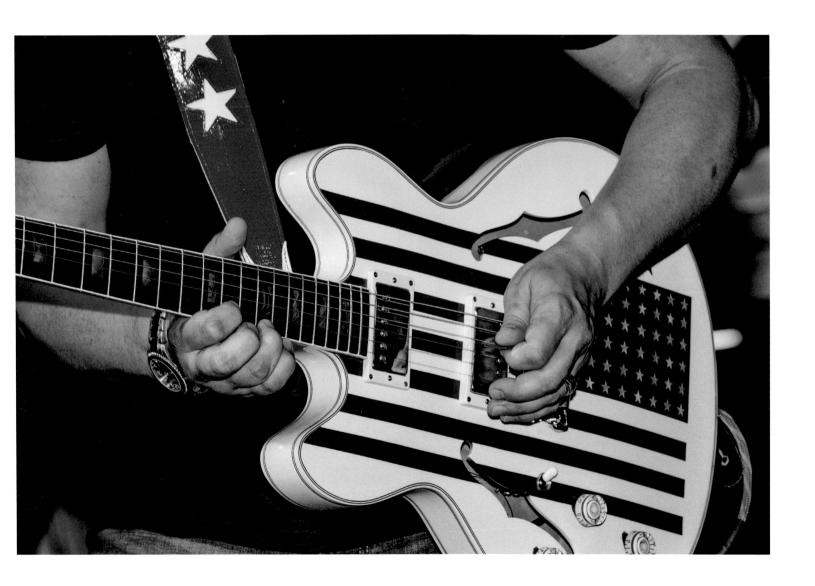

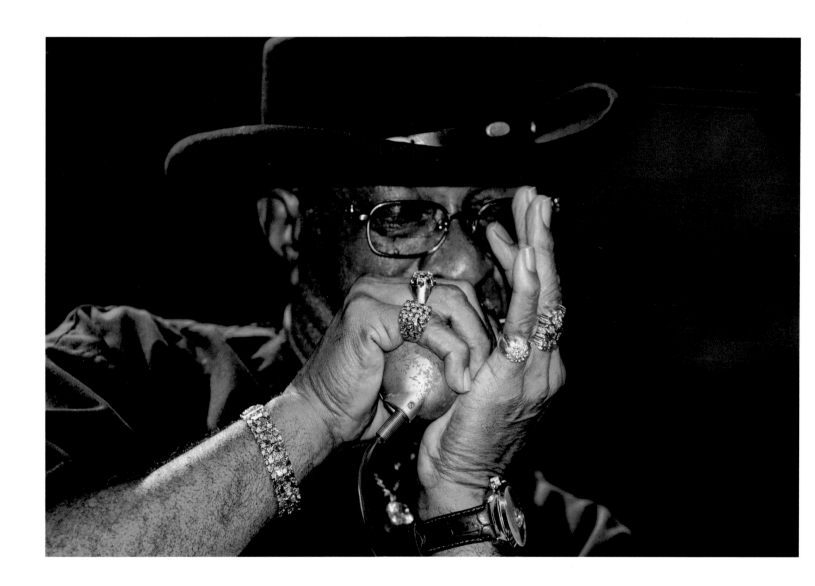

ALEXIS P. SUTER

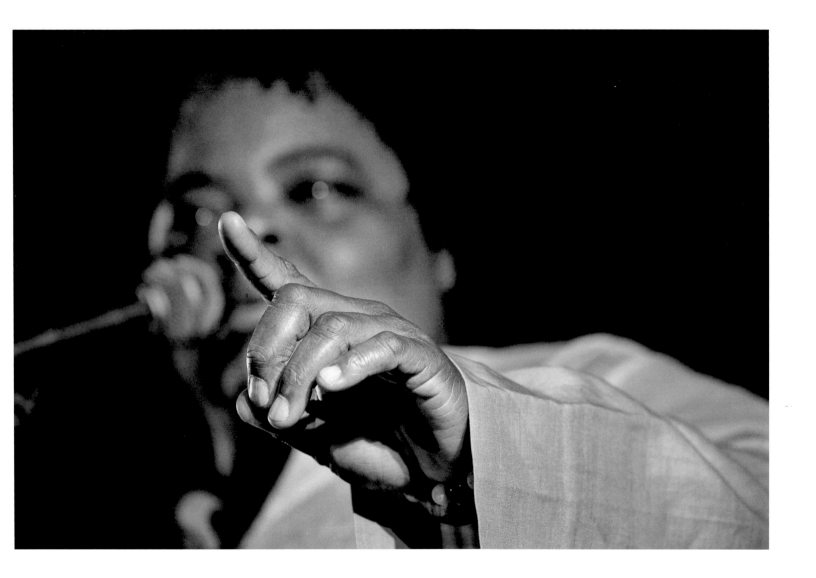

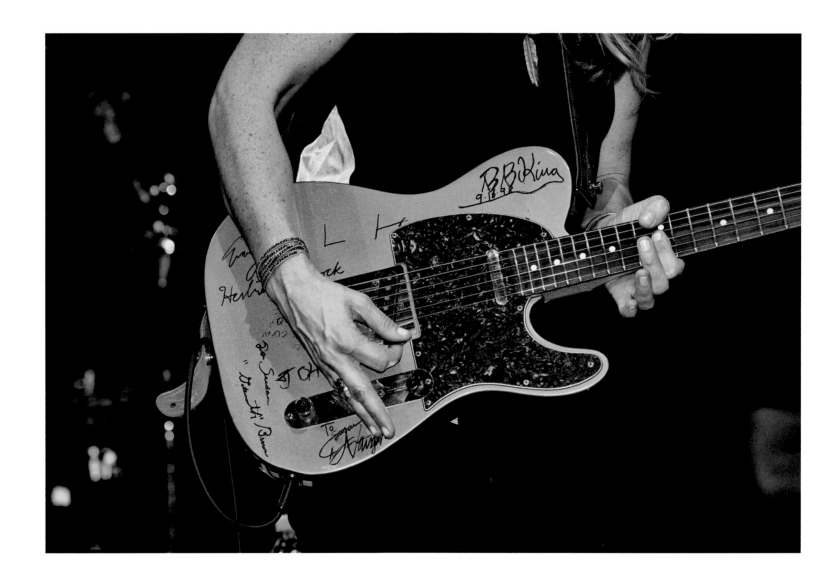

DEREK TRUCKS

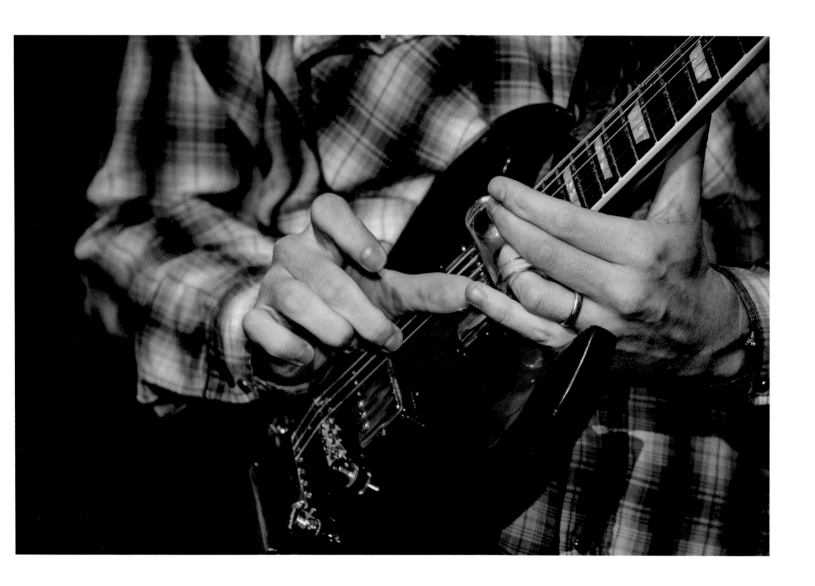

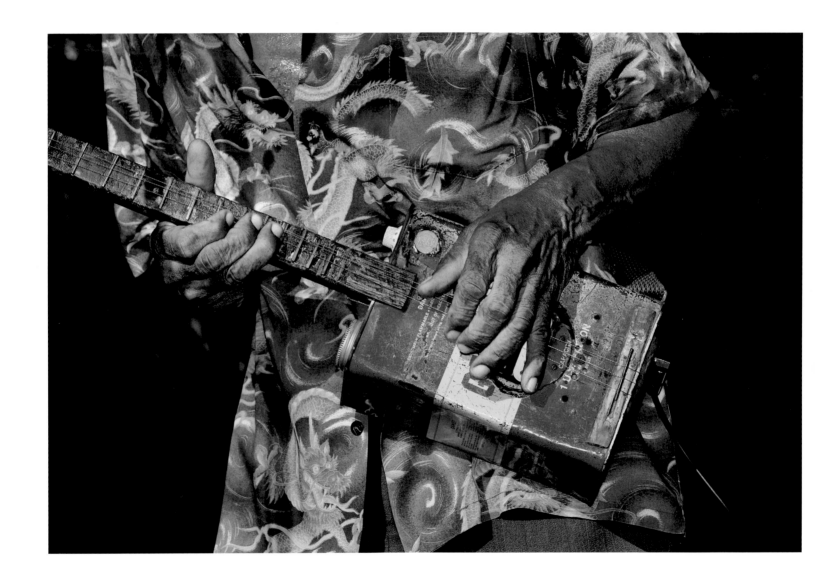

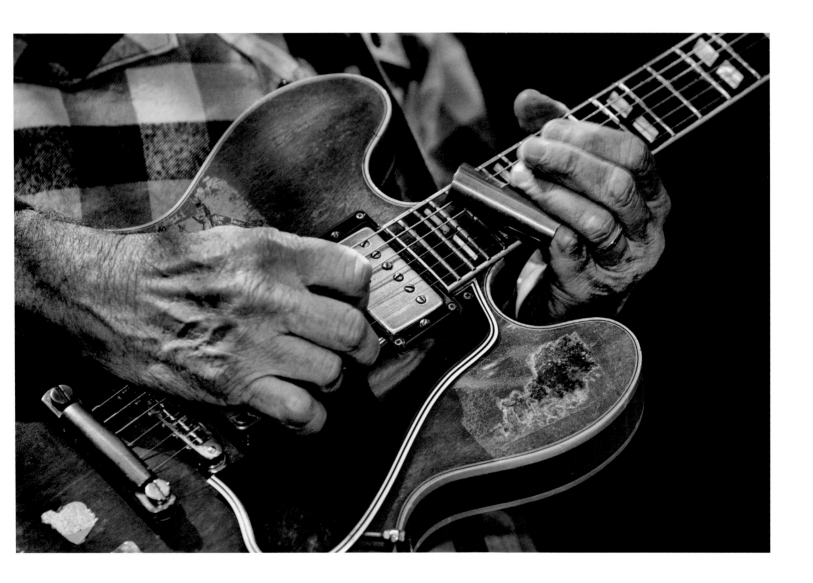

EDDIE SHAW

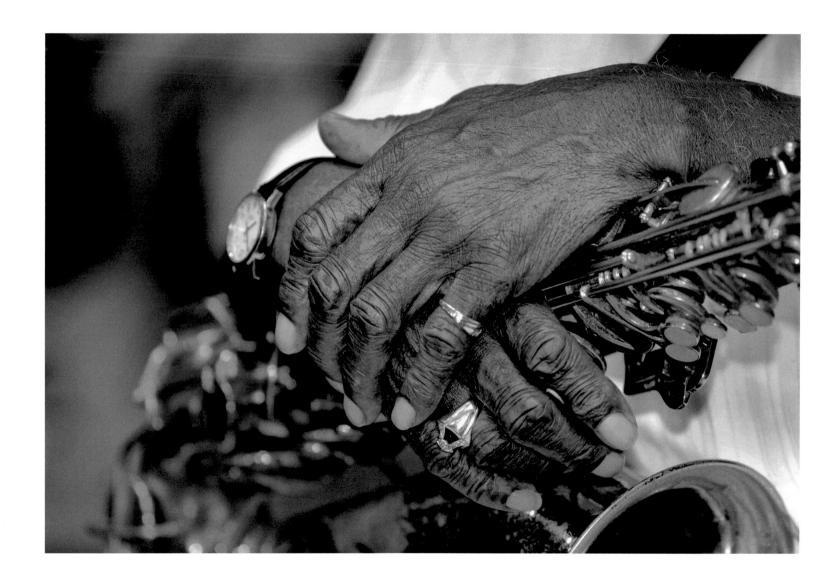

JIM RUSSELL

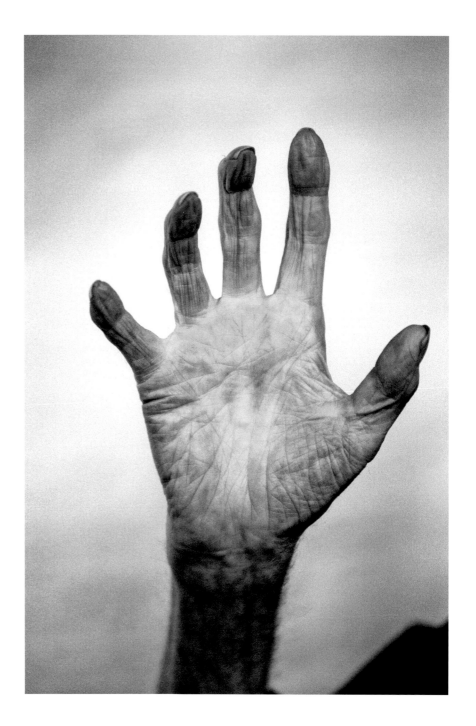

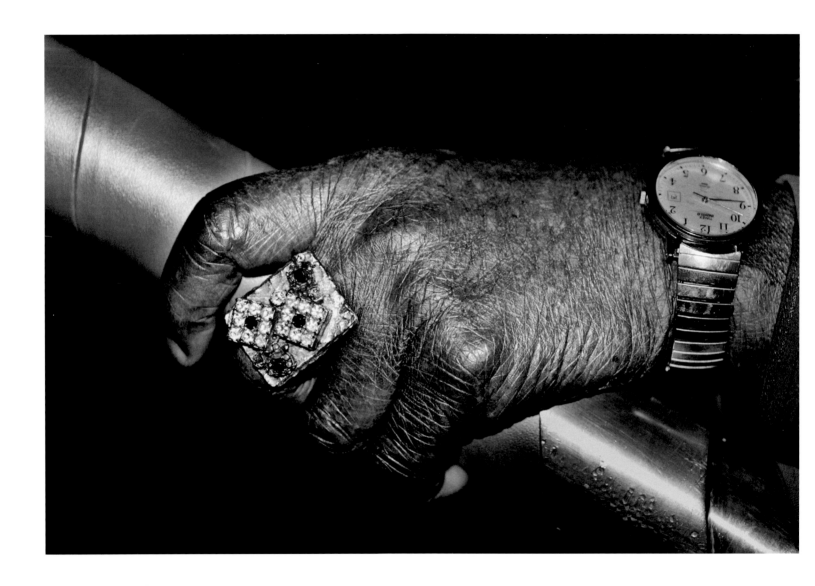

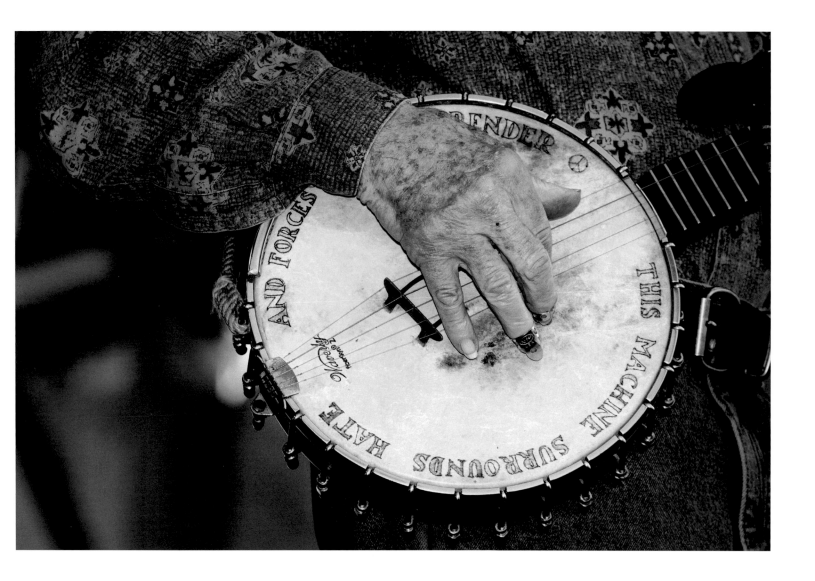

TAB BENOIT

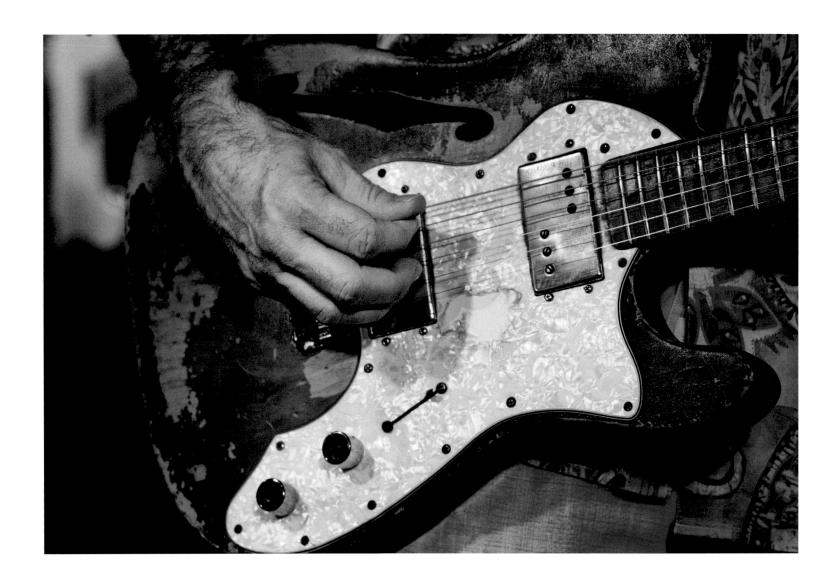

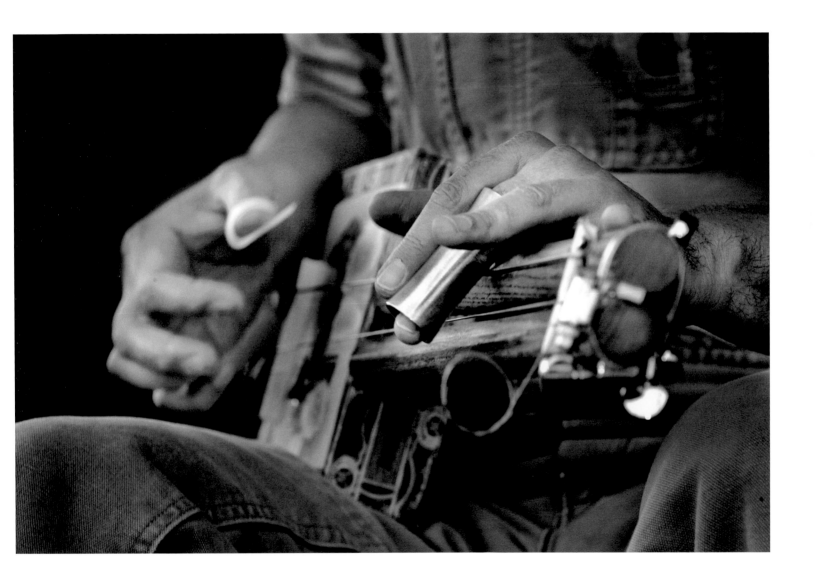

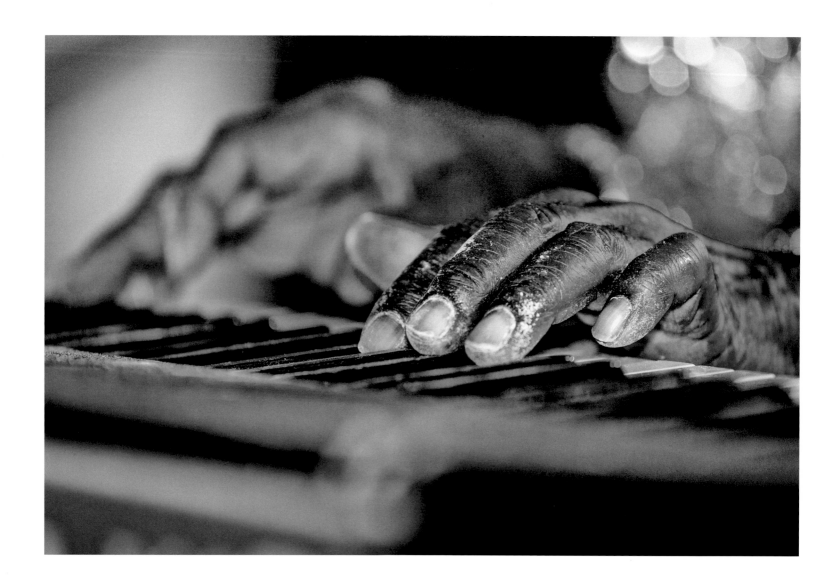

CADILLAC JOHN NOLDEN

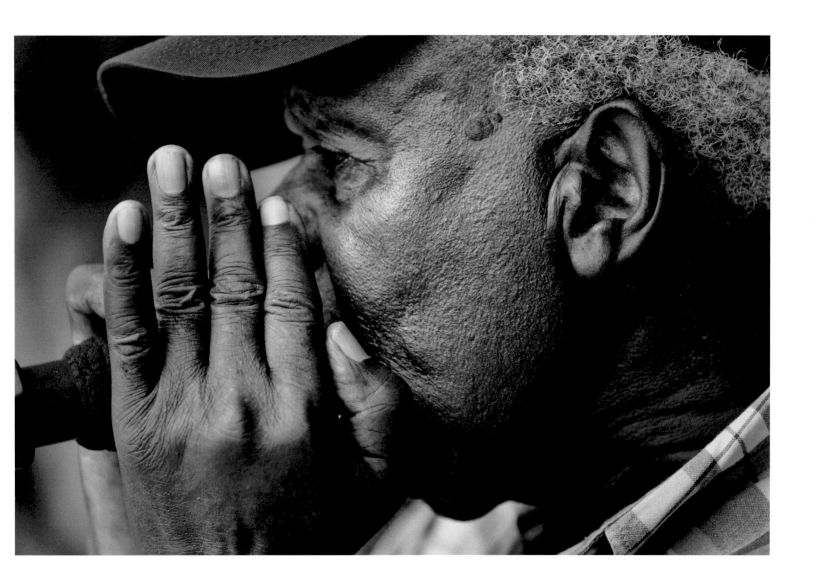

BIG CHIEF
MONK BOUDREAUX

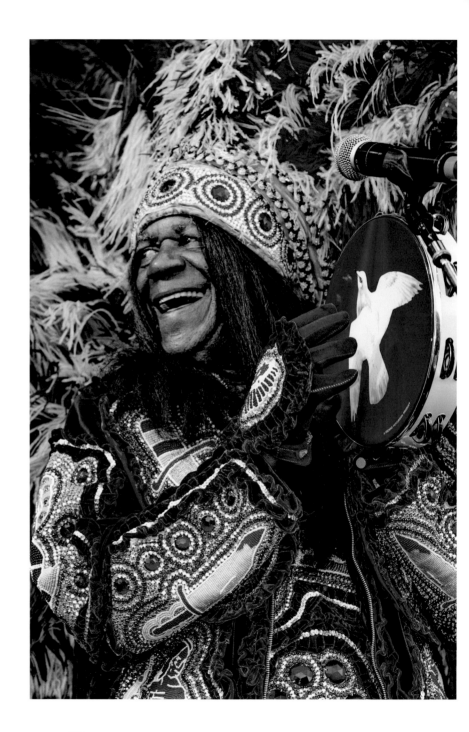

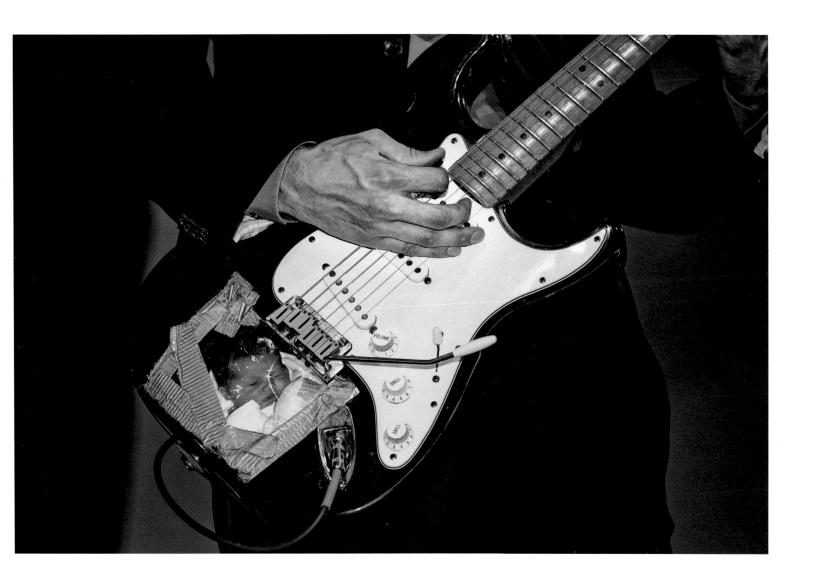

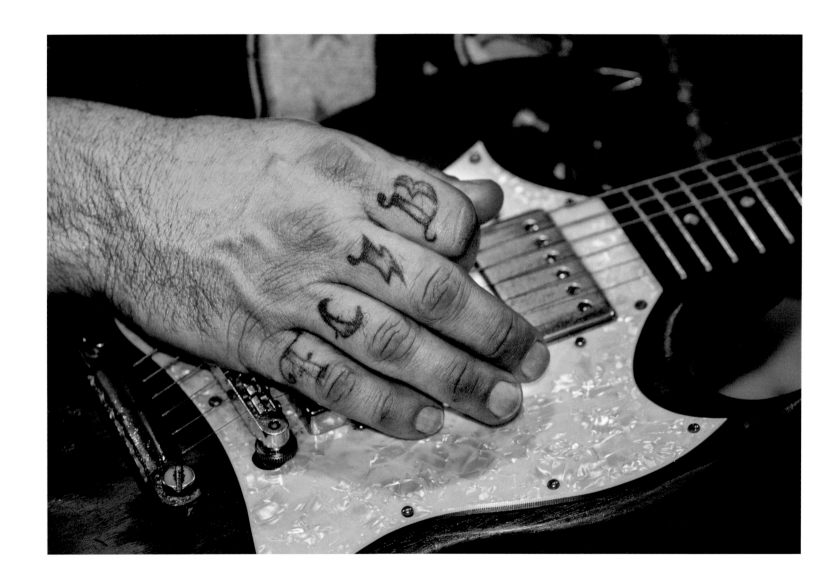

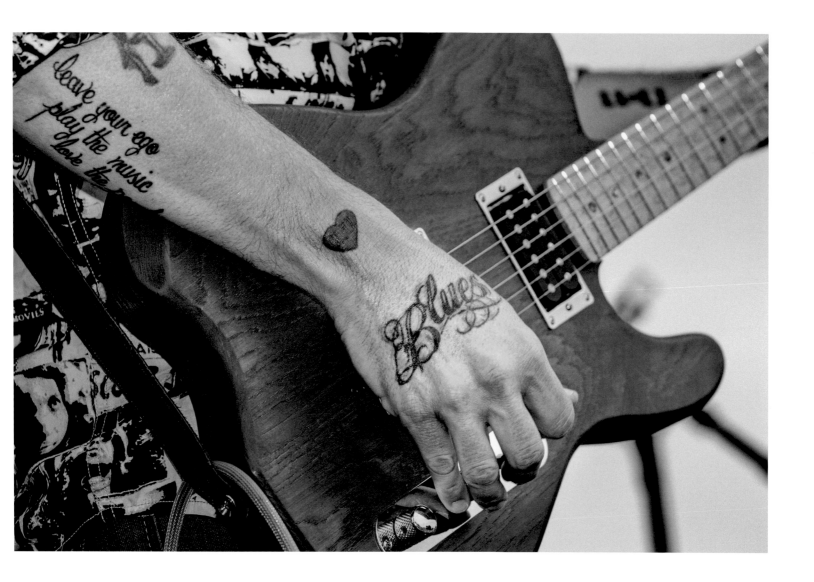

RONNIE JAMES WEBER

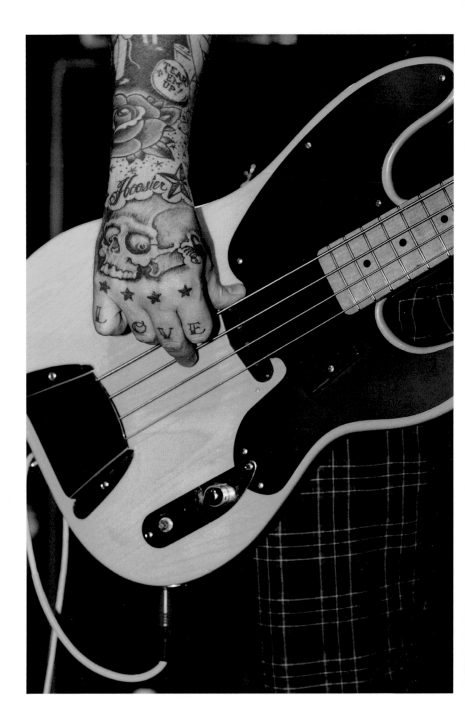

MARK WENNER

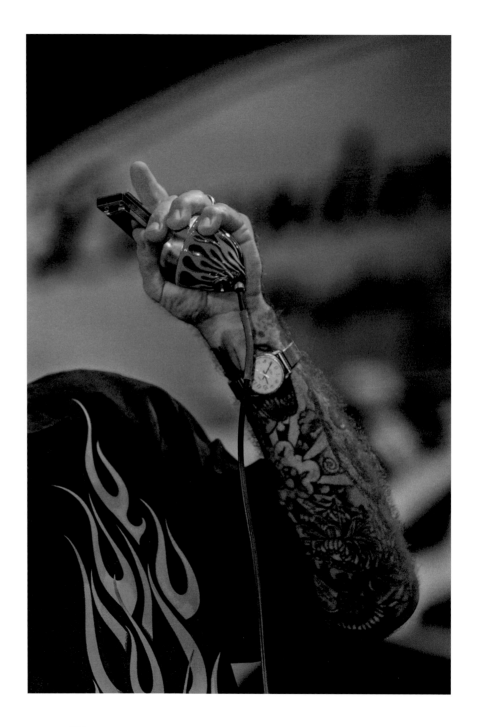

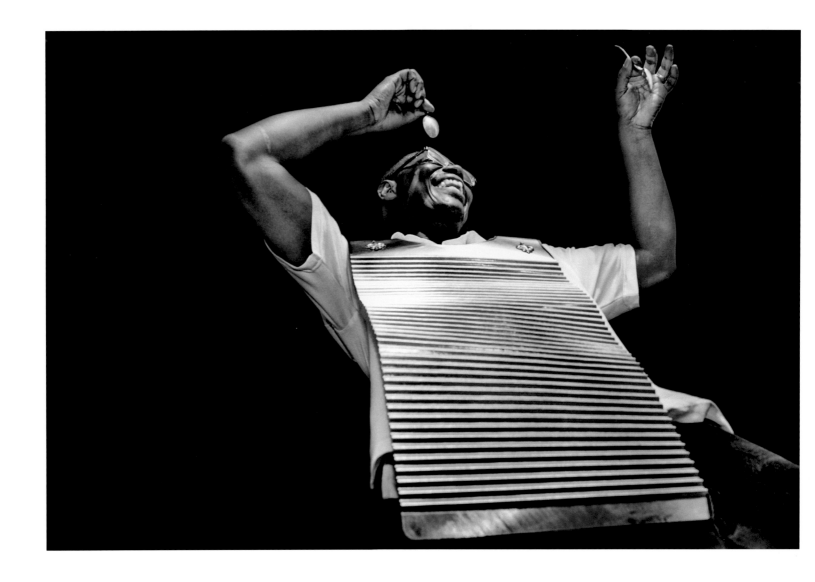

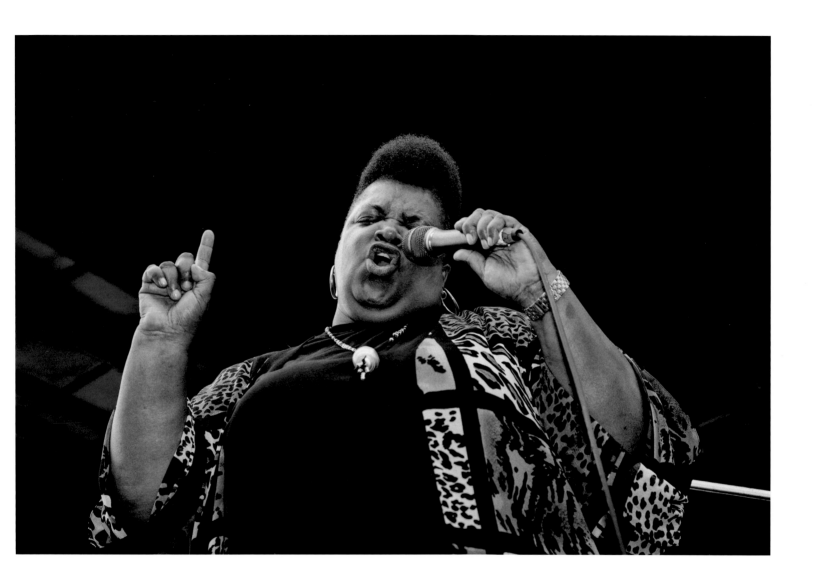

JOSEPH DALEY

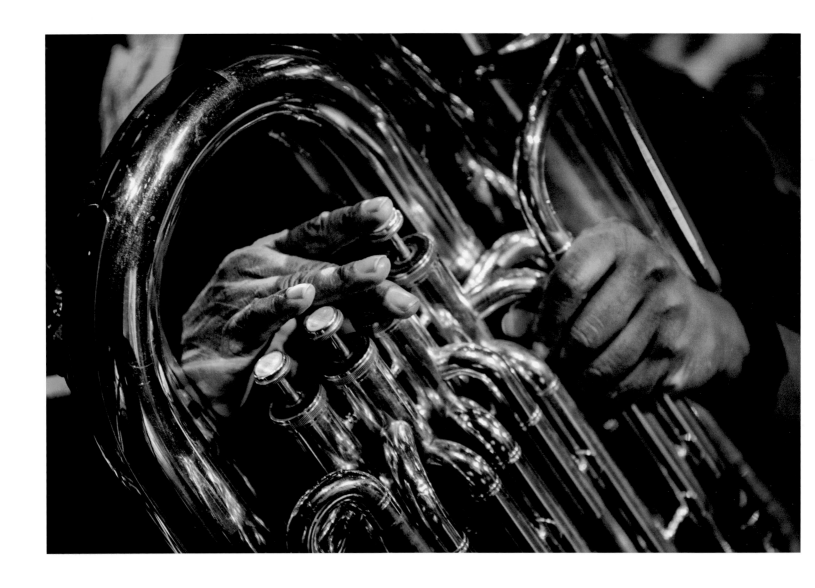

BIG JAY MCNEELY

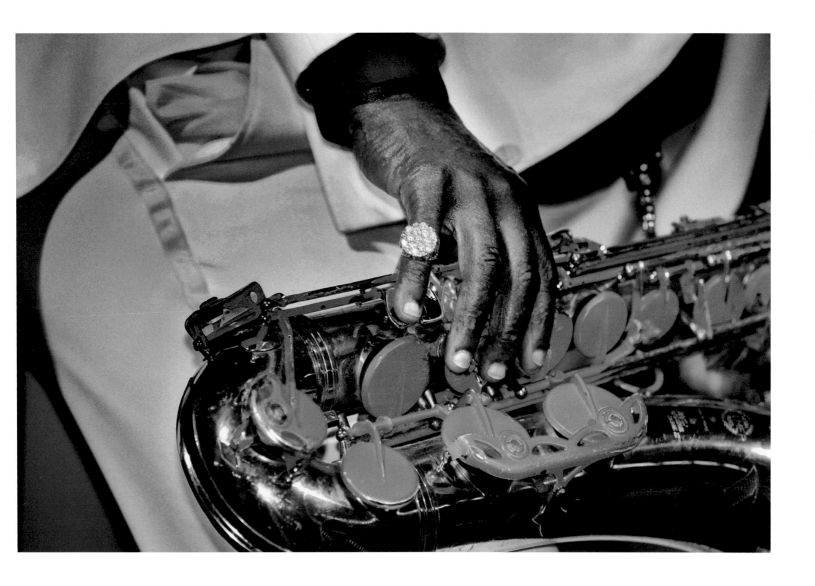

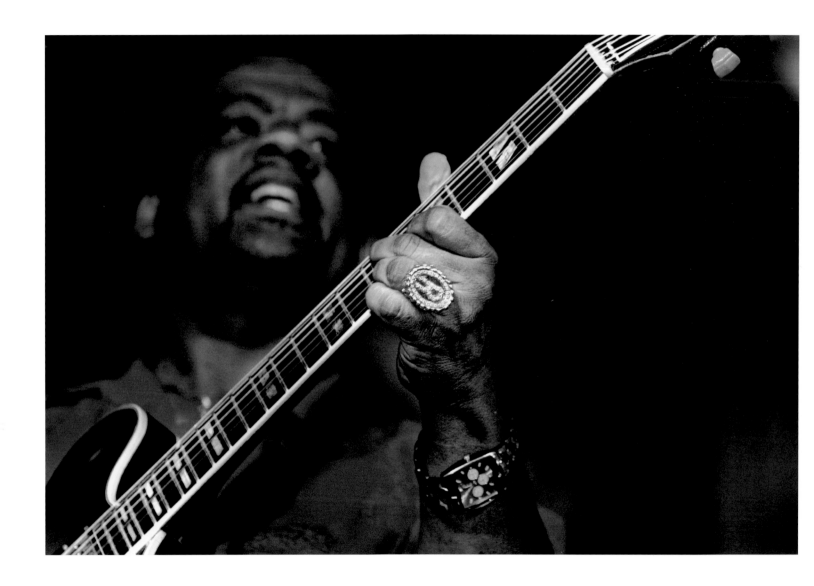

COCO ROBICHEAUX

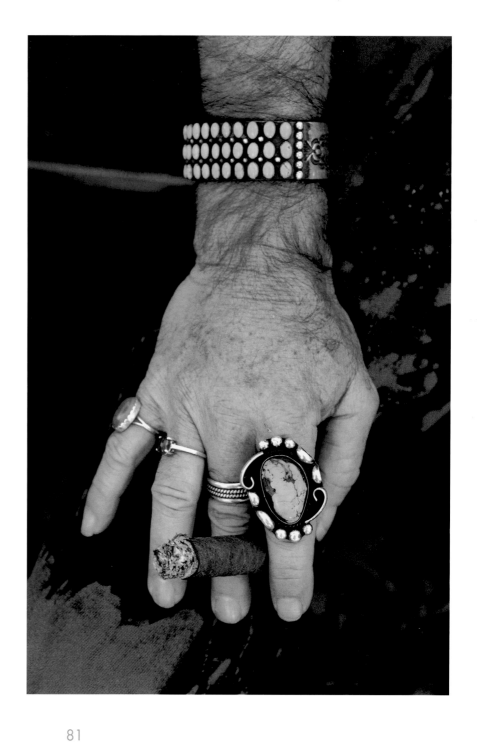

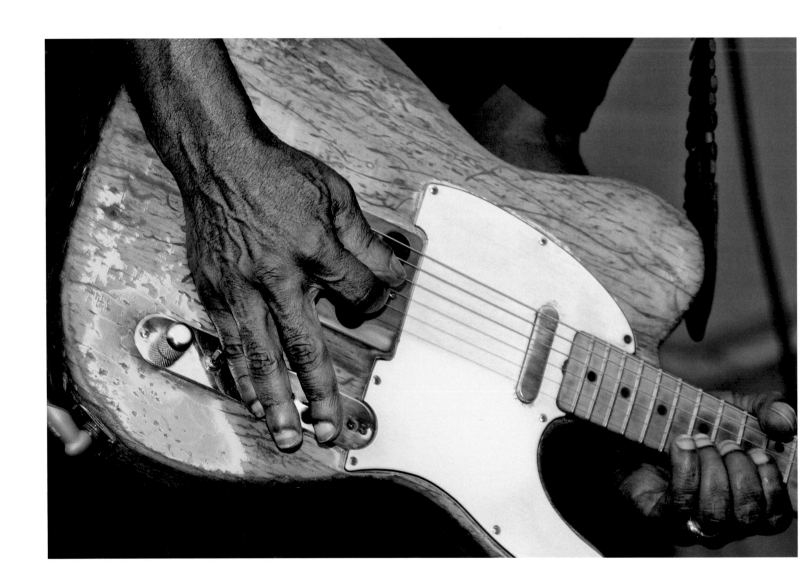

DEVON ALLMAN

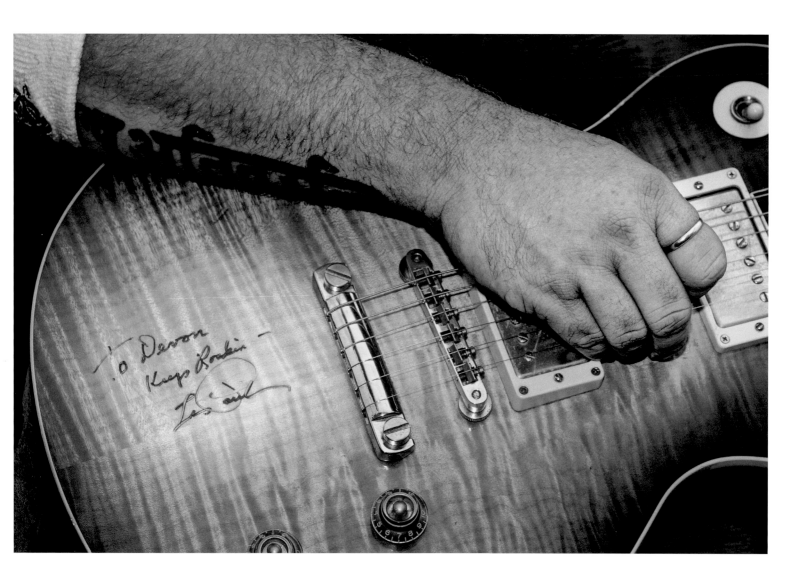

CRUSHER CARMEAN

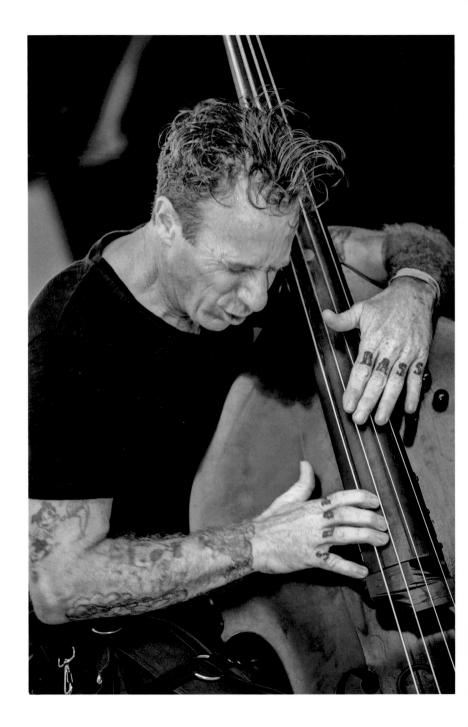

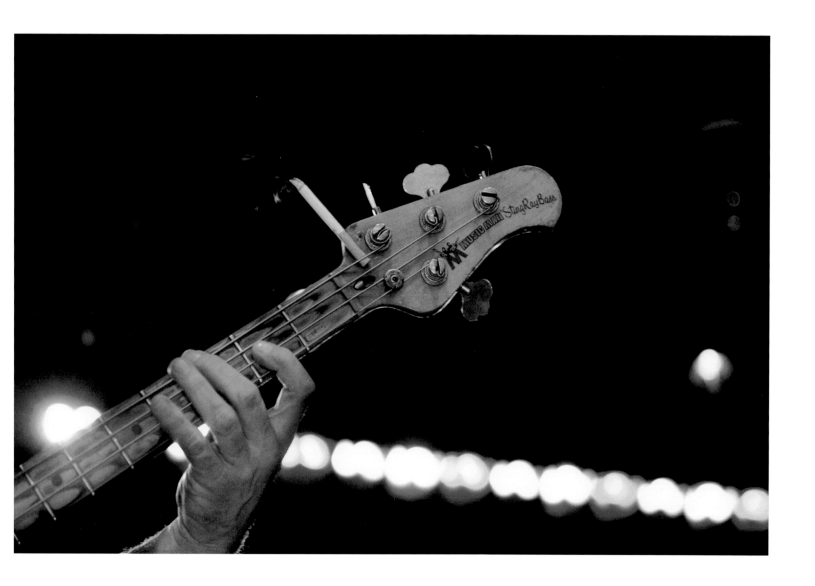

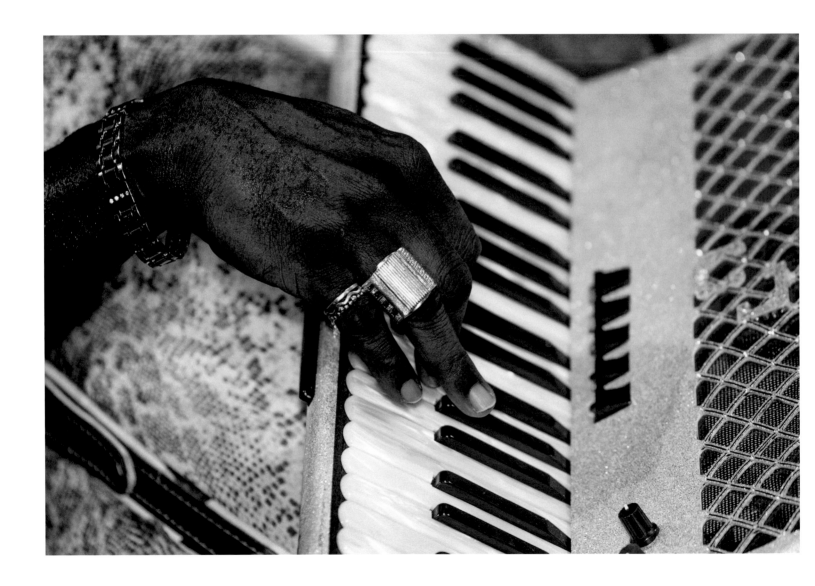

CHUCK CAMPBELL

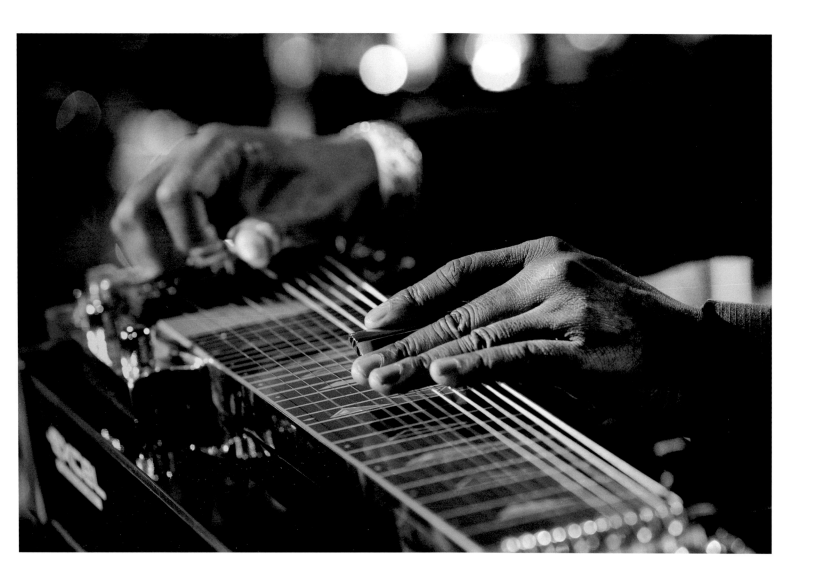

ALLEN TOUSSAINT

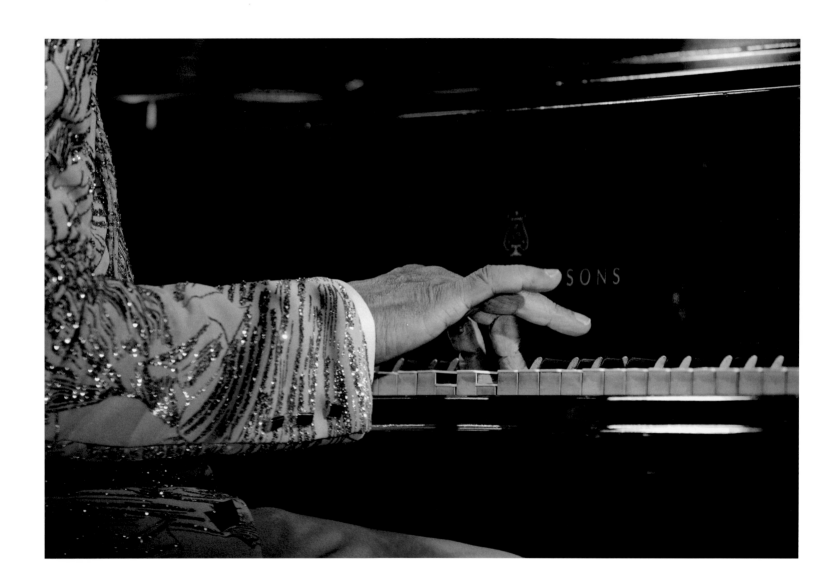

BOBBY RUSH & MIZZ LOWE

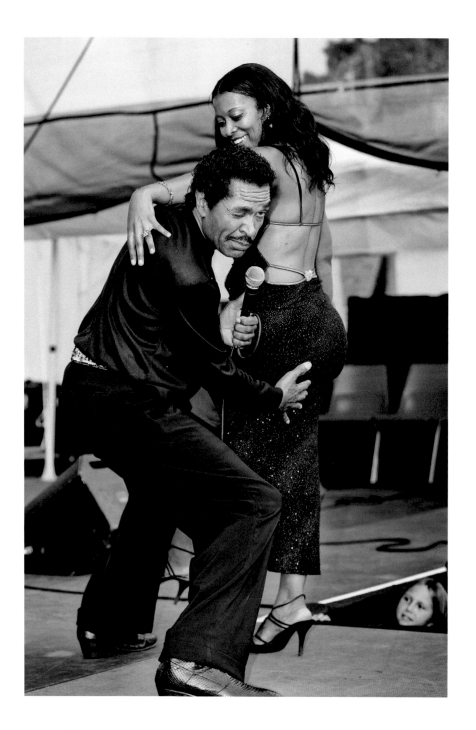

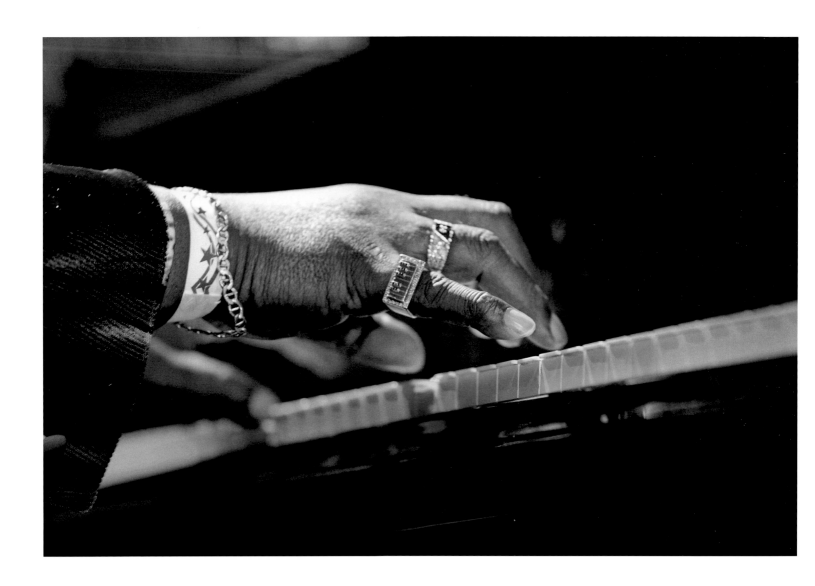

PINETOP PERKINS

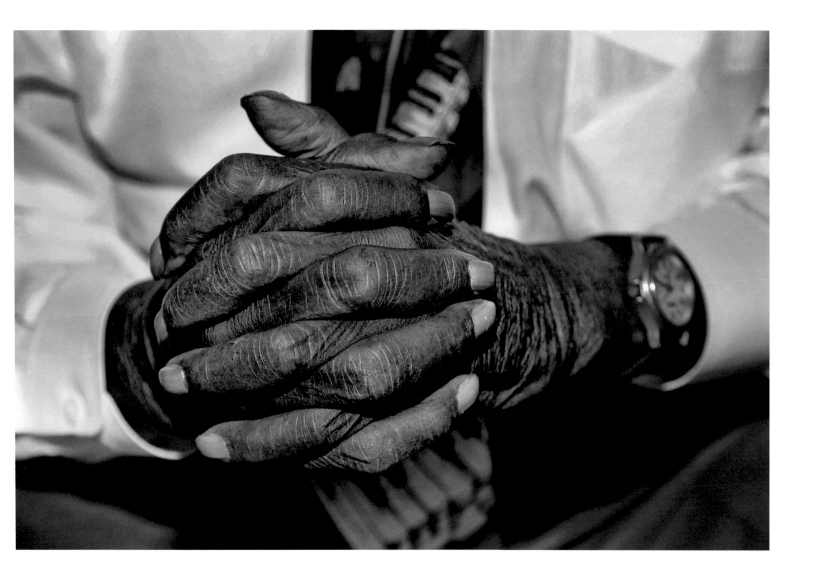

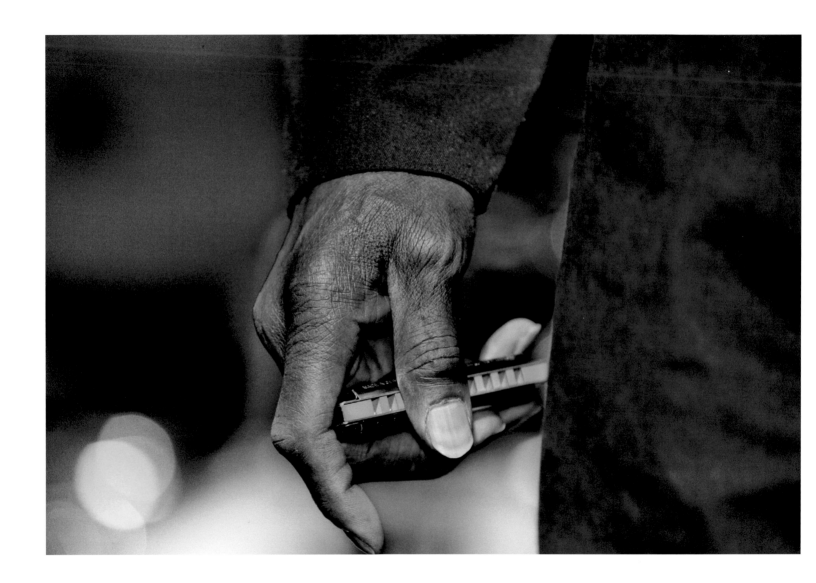

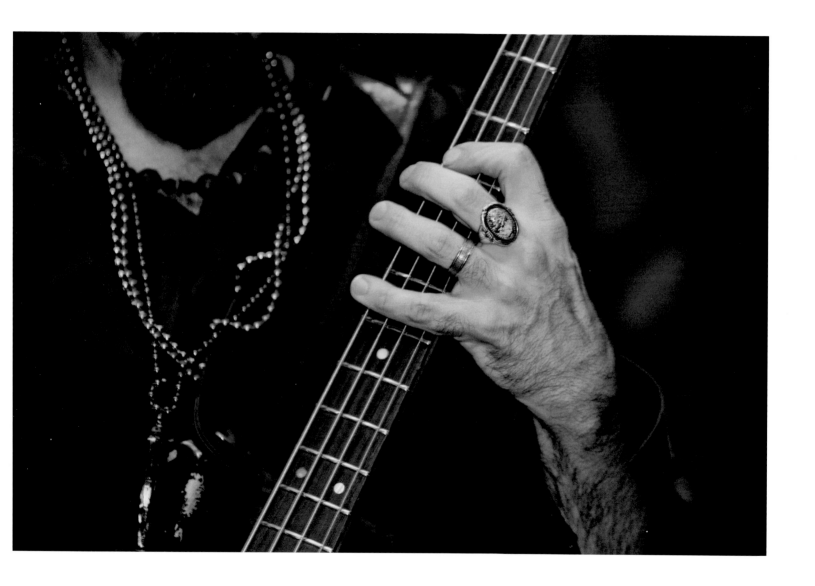

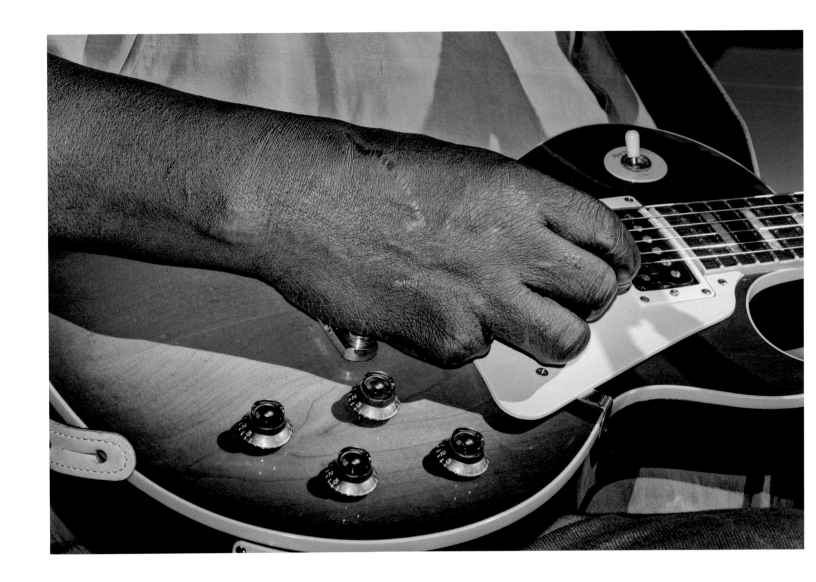

ROOSEVELT COLLIER

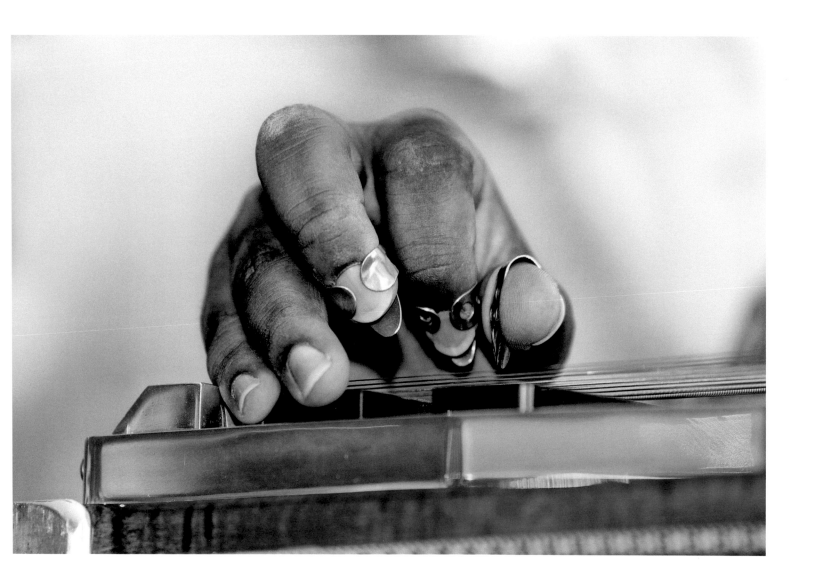

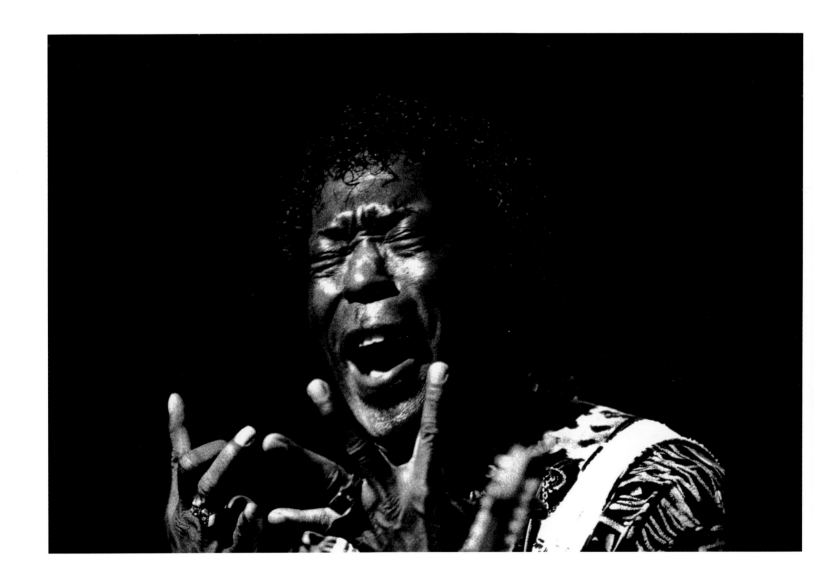

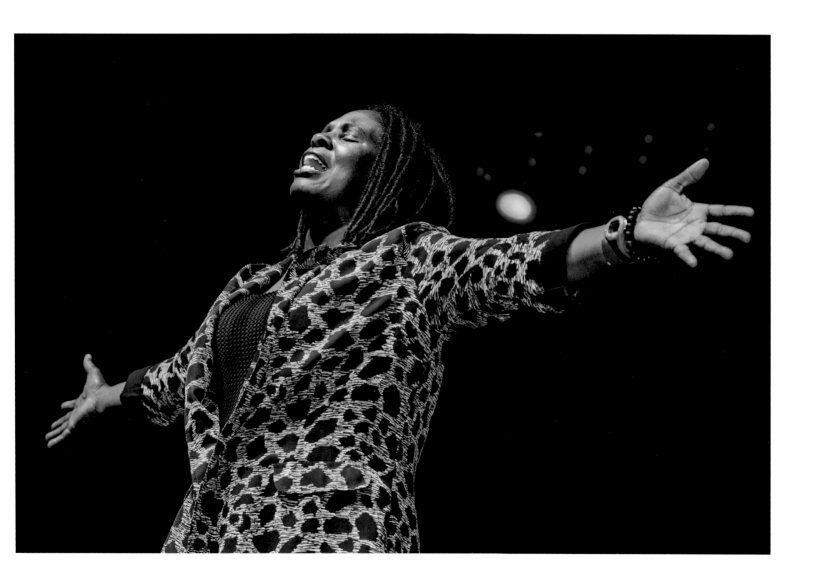

MICHAEL BURKS

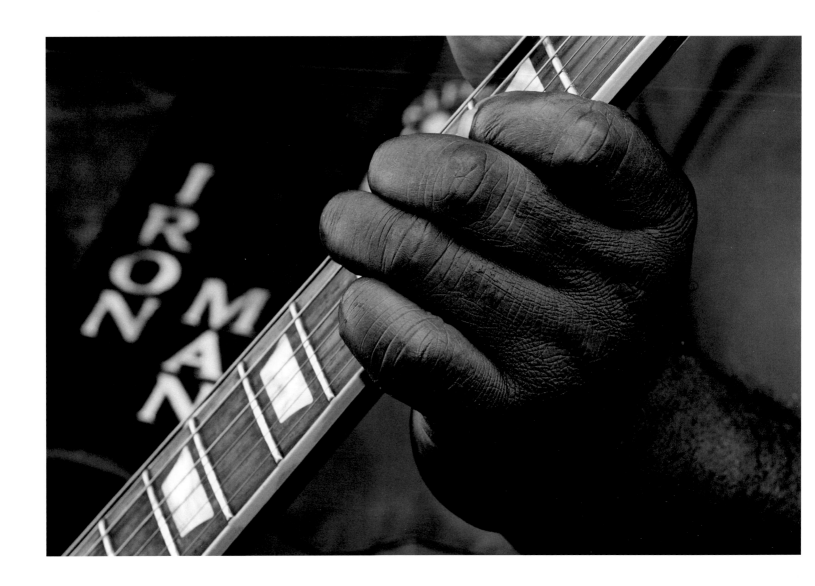

BIG JAMES MONTGOMERY

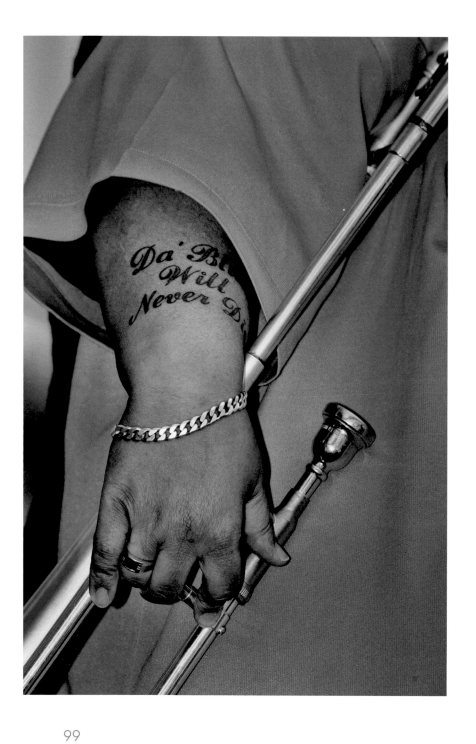

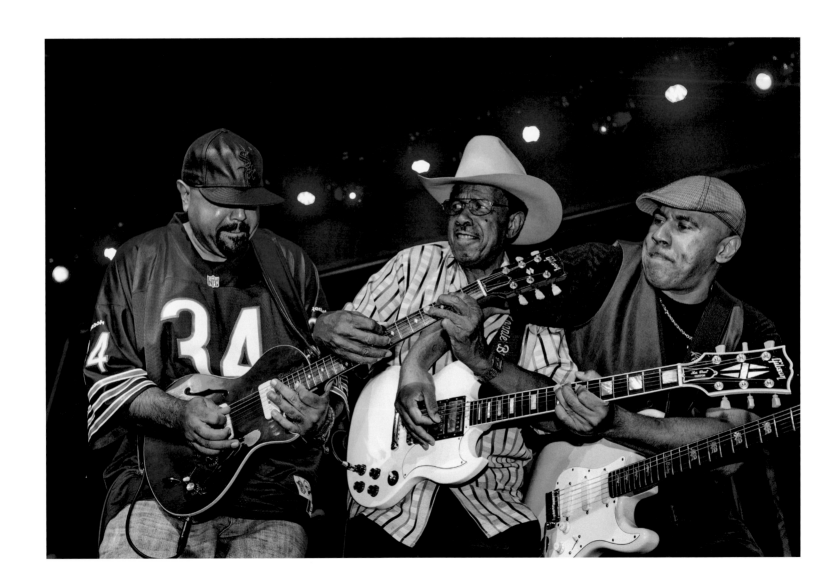

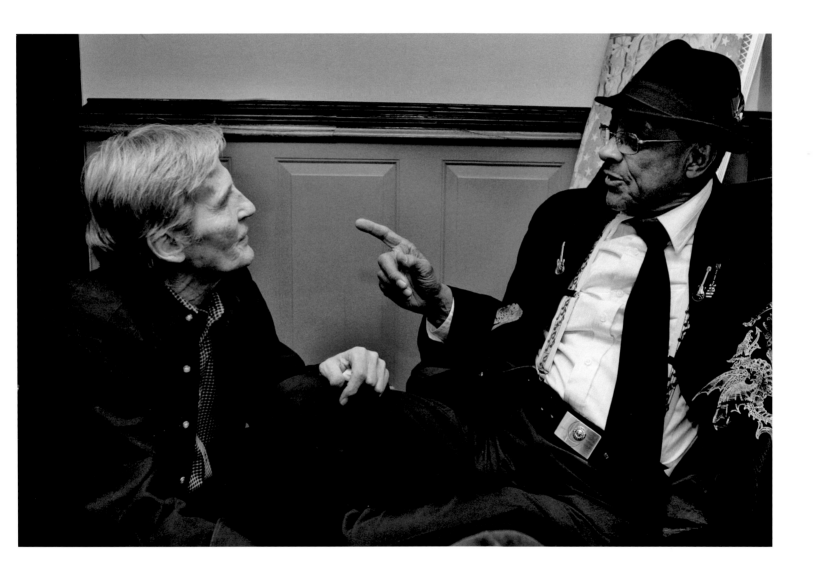

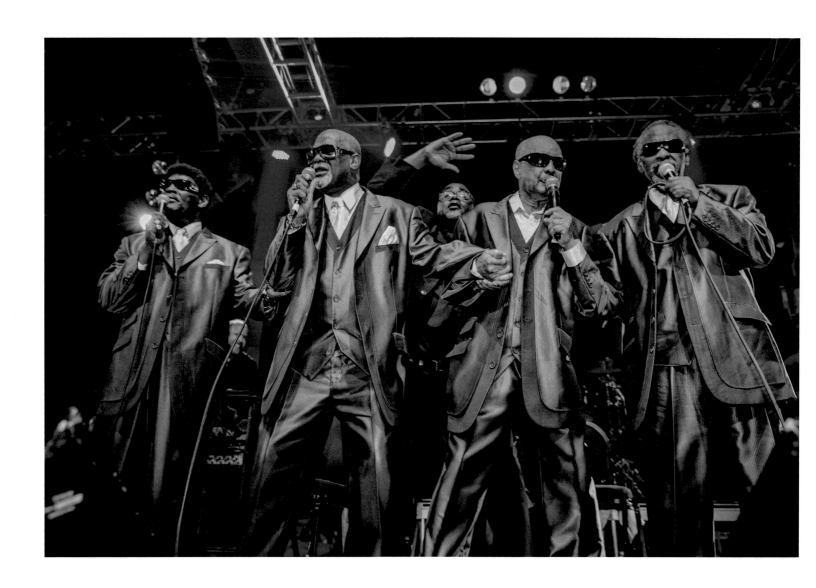

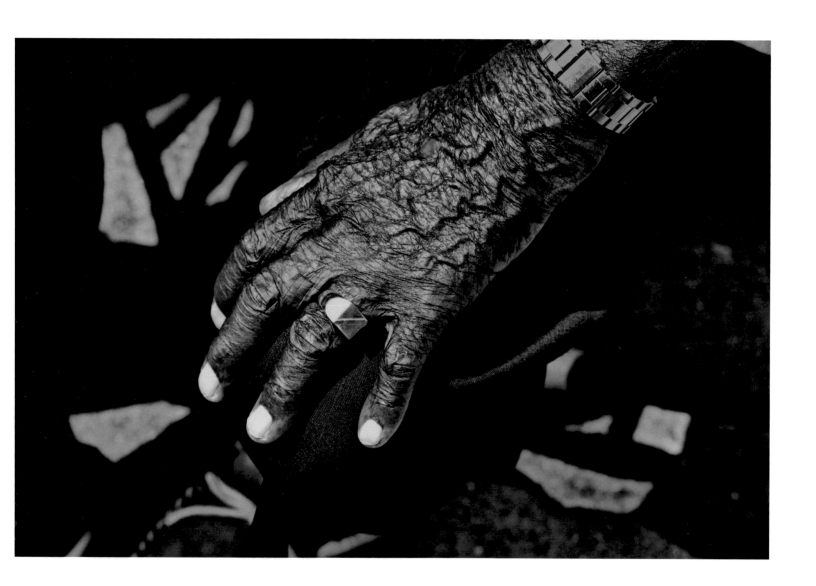

NOTES

WILLIE KING

In addition to being a Bluesman, writer of socially conscious songs, and a Juke Joint proprietor in rural Alabama, Willie created the Rural Members Association, a non-profit organization to aid and support his community. He was active in the Civil Rights movement and he used his musical skills to help others. From humble beginnings in Mississippi he went on to local, national, and international acclaim. In 1997, he founded the Freedom Creek Blues Festival that continues to this day. He left us in 2009.

Sunflower River Blues Festival, Clarksdale, MS, August 2008

TROMBONE SHORTY

Troy Andrews, aka Trombone Shorty, has deep roots in the New Orleans musical tradition. He is the younger brother of trumpeter James Andrews and grandson of R&B pioneer Jessie Hill. He got his nickname as a six-year-old bandleader. From early roots playing in brass bands to work as a sideman with the likes of Lenny Kravitz, to appearances in HBO's "Treme" and at the White House, he has matured into a full-fledged star and leader. His band—Trombone Shorty and Orleans Avenue—tours constantly, defying categorization and bridging genres and bringing joy to fans of all kinds of music.

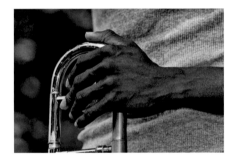

Pocono Blues Festival, Blakeslee, PA, July 2009

JOHNNY WINTER

Johnny brought me and many of my generation into the deep water of the blues. Born an albino in Texas in 1944, he was one of the first of the "Blues Rockers" to achieve popular and commercial success in the 1960s. He created an awareness and respect for the genre like few others. His music always remained deeply rooted in the Texas traditions of his youth. This photo was a "happy accident" and it is unmanipulated. Johnny sometimes used a guitar that had the tuning pegs at the bottom. The spotlight just happened to catch the top of

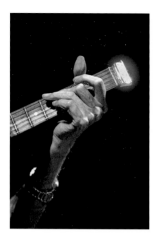

his guitar and create a "glow." Sadly, he left us in 2014, just after his 70th birthday.

Vermont Blues Festival,
Mt. Snow, VT, September 2010

SUPER CHIKAN

James Johnson—aka Super Chikan—is an original. Hailing from Clarksdale, Mississippi, in the heart of the Delta, he is part of the deep Blues tradition. As a young man, as did many before him, he started playing on a homemade instrument, the diddley bow. While he also plays regular guitar, he is pictured here playing a homemade instrument fashioned from a cigar box and a broomstick. A witty songwriter and a fine musician, he is also a folk artist. His handcrafted "Chicantars" are beautifully made and decorated, totally playable instruments of the first order.

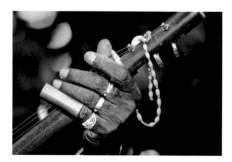

Sunflower River Blues Festival, Clarksdale, MS, August 2004

TAJ MAHAL

Born Henry Saint Clair Fredericks, he adopted the stage name Taj Mahal and the rest, as they say, is history. A multi-instrumentalist and a forceful singer, he has from his first records in the 1960s through more than forty years of recording and touring enlightened his audiences with Blues, Jazz, Caribbean, Hawaiian, African, and World music. He is both a Grammy and Blues Music Award recipient, and his contribution to American music and culture cannot be overstated.

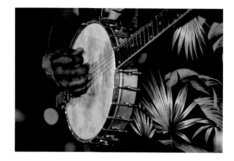

Legendary R&B Cruise, January 2008

SMOKIN' JOE KUBEK

Joe is a Texas Bluesman all the way. He grew up in Dallas in the 1960s and '70s, absorbing the sounds of Freddie King and others by playing with them in his teens. In the 1980s, he teamed up with Louisiana-born singer Bnois King. They perform all over the world, playing both hard-edged, electric Blues and Soul as well as acoustic music.

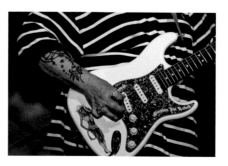

Legendary R&B Cruise, January 2008

ROY ROGERS

While he was named for the cowboy star, this Roy Rogers made a name for himself as a virtuoso slide guitarist who has led his own bands and performed, toured, and recorded with diverse artists, including Bonnie Raitt, Linda Ronstadt, Ramblin' Jack Elliott, Elvin Bishop, Carlos Santana, Steve Miller, Norton Buffalo, and Ray Manzarek of the Doors.

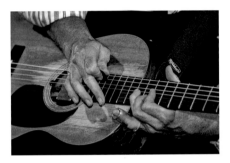

New Orleans Jazz & Heritage Festival, April 2009

MAVIS STAPLES

For me, *the* great lady of Gospel and Soul. From her Gospel roots in the '50s and '60s to Soul and Funk in the '70s, she carries on to this day. Along with her father, Roebuck "Pops" Staples, and her sisters and brother in the Staples Singers,

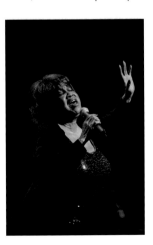

she worked closely with Dr. Martin Luther King. Their music was often called the soundtrack of the Civil Rights movement. I am honored and humbled that I occasionally get to breathe some of the same air as Ms. Staples. This photo was taken at the Apollo Theatre (she was on a Gospel bill with Al Green) and wound up on the cover of *Blues Revue* magazine. I am proud to have a signed copy hanging on my wall.

Apollo Theater, New York, NY, October 2005

LES PAUL

Lester William Polsfuss, aka Les Paul, is an American icon. His influence as an inventor, innovator, and musician is beyond measure. He was a pioneer in sound recording and instrument making, refining or creating the solid body electric guitar, sound on sound recording, tape delay and echo effects, and much more. Early in his career as a guitarist, he recorded solo and with many

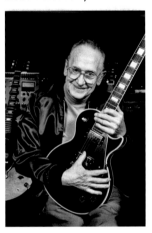

Jazz greats. Later, in the 1950s, with then-wife Mary Ford, he became hugely popular as a performing and recording artist and a TV personality. This photo was taken on assignment for the *New York Times* on his eightieth birthday at his home studio in New Jersey. He is pictured holding the classic guitar that bears his name; it is Les Paul with a Les Paul.

Mahwah, NJ, May 1995

EUBIE BLAKE

James Hubert "Eubie" Blake was a Ragtime pianist and composer born before the turn of the twentieth century who was still going strong when I took this picture in 1982. He first became famous for his vaudeville collaboration with Noble Sissle. Their 1921 musical *Shuffle Along*— considered the first Broadway hit by and about African-Americans — produced the wildly popular song "I'm Just Wild About Harry." He went on to compose hundreds of songs over the next sixty years. I took this photo at a press event where Blake was presented a video disc player and the first stereo video disc of the Broadway musical *Eubie!* He was

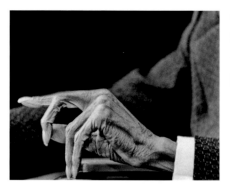

well into his nineties at the time and sharp, funny, and "salty."

New York, NY, May 1982

LC ULMER

Born in 1928, Lee Chester "LC" Ulmer is a true Bluesman and a true character. He traveled extensively for many years, working various jobs as well as playing music, and returned home to Mississippi in 2001. You can't see it here, but he wore three or four wristwatches and offered a lengthy

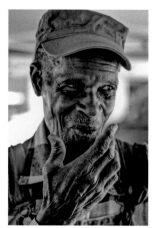

explanation of the need for each one. Even though he is obviously old and weathered, there's a youthful, impish, mischievous quality about him that I hope I caught here.

Juke Joint Festival,
Clarksdale, MS,
April 2010

FRANK CHRISTIAN

Frank was a dear friend and a supremely talented player and singer/ songwriter—a musician's musician. He performed beautifully in a variety of genres: Blues, Folk, Jazz, and more. Sadly, he left us far too soon on

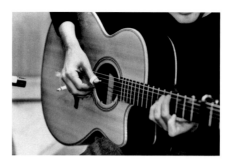

Christmas Eve, 2012. This was the gatefold photo for his CD "From These Hands." Rest in peace.

Recording Studio, New York, NY, January 1995

SHAKURA S'AIDA

Born in Brooklyn, raised in Switzerland, and living in Toronto, Shakura is a world class talent and a great friend with a wicked sense of humor. She also has a powerful voice and stage presence and years of experience in theatre and dance. Whether performing with a small group or a symphony orchestra, she gives shows that are, in the best sense of the word, "theatrical."

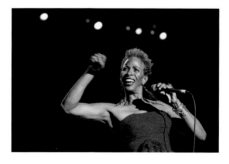

Legendary R&B Cruise, January 2012

IRMA THOMAS

Ms. Thomas is the "Soul Queen of New Orleans," a title she has held since her first hit "(You Can Have My Husband But) Don't Mess With My Man"

in 1960. She had a string of hits that have become New Orleans standards, including "It's Raining," "Ruler of My Heart," and the original version of "Time Is On My Side," which the Rolling Stones covered or stole, depending on who you ask. I like to think this photo captures some of the personal warmth of a local legend and an international star.

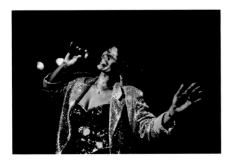

Tramps, New York, NY, October 1992

SHARDE THOMAS

Cane fifes—Ms. Thomas learned to play them and make them at the knee of her grandfather, Othar Turner. Fife and drum music—which dates back to slavery times and was originally an African-American take on colonial English marching songs—runs deep in the traditions and culture of the Mississippi Hill Country. Ms. Thomas carries on the art form locally and nationally with the Rising Star Fife and Drum Band.

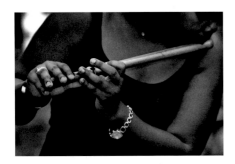

Sunflower River Blues Festival, Clarksdale, MS, August 2006

HARRISON KENNEDY

Kennedy's story is unique. He enjoyed huge hits and popular success as a member of the Soul super group Chairmen Of The Board in the late '60s

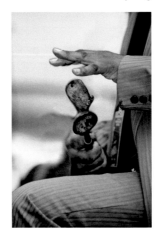

and '70s. After that ran its course, he returned to his native Hamilton, Ontario, and to his original love: simple, heartfelt Soul and Country Blues. A cancer survivor, Kennedy is pictured here accompanying himself on the spoons.

Pocono Blues Festival, Blakeslee, PA, July 2009

LOUISIANA RED

Iverson Mintner, aka Louisiana Red, was a true Bluesman. Orphaned after his mother died and his father was lynched, he was raised by relatives. He recorded in the late '40s for Chess Records, did a stint in the Army, and returned to music, performing and recording continuously until he passed in 2012. I got to know Red when he lived in Pittsburgh in the '70s and performed locally—occasionally even on my radio program. When he played—especially solo and acoustic—he seemed transported trance-like to another, deeper place. I am grateful our life paths crossed.

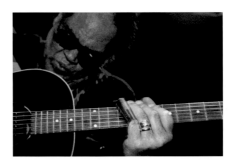

Ponderosa Stomp, New Orleans, LA, April 2008

B.B. KING

The King of the Blues. No one has done more to bring Blues to the world than B.B. King. A genius and a true gentleman, he is a member of the Blues Hall of Fame and the Rock 'n Roll Hall of Fame, and has been awarded the National

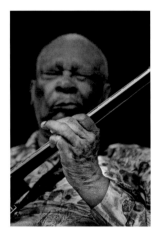

Medal of Arts, the National Heritage Fellowship, the Kennedy Center Honor, and the Presidential Medal of Freedom. From humble Mississippi beginnings to worldwide recognition and stardom, he has defined class and dignity. I am proud to say I remember sneaking into his gigs in the late '60s as an underage teen. He left us at age 89 in 2015. Rest in peace.

New Orleans Jazz & Heritage Festival, May 2010

AL GREEN

Al Green was the king of sexy southern Soul in the '60s and '70s, with huge hits and great success. But he gave it all up to open a church and ministry in his hometown of Memphis and for many years sang only his unique version of Gospel music. He later returned to singing secular music in addition to Gospel and continues to record and give electrifying live performances. He is a member of both the Rock and Roll and Gospel Music Halls of Fame.

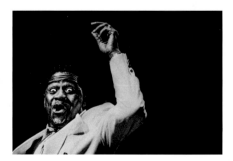

Benson & Hedges Blues Festival, Beacon Theater, New York, NY, 1991

JAMES BROWN

Soul Brother Number One. The Godfather of Soul. James Brown was a force of nature. From early R&B hits to genre-defining Soul and Funk hits and through ups and downs in life, he was an astonishing singer and dancer, an exacting band leader, and a businessman, social activist, and more. His live performances were legendary for their energy and showmanship. I am glad I got to see and photograph him perform while he had all his powers, as in this photo.

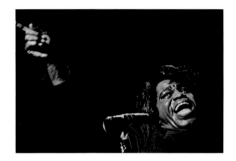

The Savoy, New York, NY, c. 1983

CHUCK JACKSON

R&B and Soul pioneer. Chuck Jackson was a member of The Del-Vikings, one of the few racially integrated musical groups to attain success in the 1950s. He went on to a solo career with hits like "Any Day Now" and "I Don't Want to Cry" and a series of duets with Maxine Brown. He was one of the first singers to record Bacharach-David songs. In 1992, he was awarded the Rhythm & Blues Foundation's Pioneer Award.

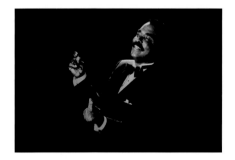

Photo studio for the Rhythm & Blues Foundation, New York, NY, 1994

MAXINE BROWN

Beautiful and ageless, Maxine Brown personifies soulful elegance. She had early roots in Gospel, then hits like "All in My Mind" and "Oh No, Not My Baby," and added a series of successful duets with Chuck Jackson. Then she had another string of solo hits, often with backing vocals by Cissy Houston and the Sweet Inspirations. In 1991, she was awarded the Rhythm & Blues Foundation's Pioneer Award.

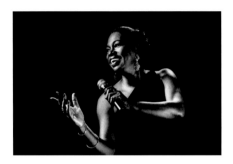

Photo studio for the Rhythm & Blues Foundation, New York, NY, 1994

KIM WILSON

Kim was a founding member of the Fabulous Thunderbirds, who along with Robert Cray and Stevie Ray Vaughan (brother of original Thunderbirds guitarist Jimmie Vaughan) brought Blues to MTV and the masses in the '80s. A new incarnation of the Thunderbirds tours and records extensively. Kim is a powerful vocalist and harmonica player who pretty much set the bar for those who followed. He and I shared a deep friendship with the late Pittsburgh Blues DJ Big Al Smith.

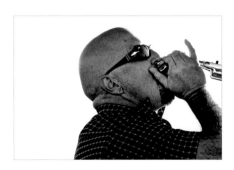

Legendary R&B Cruise, October 2006

CHARLIE MUSSELWHITE

Charlie, along with Paul Butterfield and Michael Bloomfield, was one of the first white artists to bring authentic Blues to broader audiences in the mid '60s. His 1967 LP "Stand Back" stands as a classic. Born in Mississippi, he lived in Memphis and Chicago and is deep in the tradition of the Blues. He is both a Grammy and a Blues Music Award winner and a true gentleman to boot.

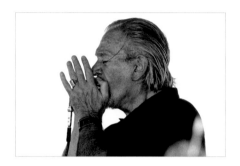

Legendary R&B Cruise, January 2008

BUCKWHEAT ZYDECO

Stanley Dural Jr., aka Buckwheat Zydeco, is a great friend and a great musician. As a Grammy-winning ambassador for Zydeco—the Creole music of southwest Louisiana—he tours the world, bringing music, joy, and culture to audiences everywhere. He is associated with the accordion—the traditional lead instrument in Zydeco—but he is pictured here playing the Hammond organ, his original instrument. Stanley told me that when organ players cross their hands like this it's called "going cross country." I love the way the black and white here is in the form of rectangles and right angles.

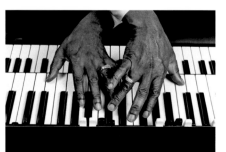

Recording Studio, Woodstock, NY, April 2005

JELLYBEAN JOHNSON

Best known as the drummer for the band Time and as a producer and session musician, Jellybean was on the Legendary R&B Cruise, playing and

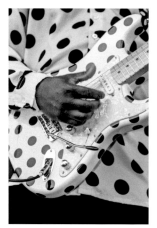

working with Ronnie Baker Brooks. I love the way the black and white here is in the form of circles and ovals and the shirt echoes the guitar.

Legendary R&B Cruise, October 2008

JOE LOUIS WALKER

Joe Louis Walker is one of the youngest members of the Blues Hall of Fame. Hailing from the Bay Area, he got an early start there playing with the likes of John Lee Hooker, Mike Bloomfield, and more. After a stint with The Spiritual Corinthians Gospel Quartet he formed the BossTalkers Blues band. A prolific artist, he went on to record for, among others, Hightone, Verve, Stony Plain, JSP, Telarc, and most recently Alligator. I love the contrast of the brass slide and the diamond ring.

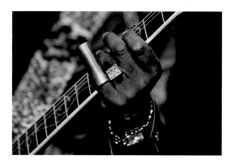

Legendary R&B Cruise, October 2007

RICHIE HAVENS

Richie gained fame as a singer-songwriter and a Folk musician, but there was always a lot of Blues in his music. He is perhaps best known for his performance at Woodstock, where he was the first act to perform. Due to massive traffic jams, the following acts were yet to arrive and he did a three-hour set with multiple encores. I had the occasion to work with him once or twice and he was a kind and gentle soul.

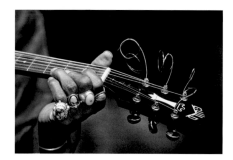

New Orleans Jazz & Heritage Festival, April 2007

FRANK "SCRAP IRON" ROBINSON

"Scrap Iron" is a good friend and a real character. He spent thirty years on the Chitlin' Circuit as Little Milton Campbell's road manager. He watched the door, the money, and Milton's back. He has some great stories to tell. Twice a year he serves as a Master of Ceremonies on the Legendary R&B Cruise.

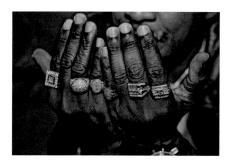

Legendary R&B Cruise, October 2009

EDDIE DANIELS

A Louisiana native transplanted to Los Angeles, Eddie has a career spanning over fifty years of Rock 'n Roll. A staple of the Los Angeles scene as a

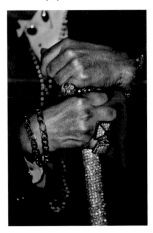

recording artist and session player, he was there at the beginning of West Coast Rock 'n Roll. He still performs with the Amazing Platters and promotes his "Ghetto Baby" line of clothing.

Ponderosa Stomp,
New Orleans, LA, October 2013

GARY CLARK JR.

Born in 1984, Clark is being called the face and future of the Blues. He got his start as a teenager when legendary Texas club owner Clifford Antone supported him and introduced him to Austin's best, such as Jimmy Vaughn, Denny Freeman, and Derek O'Brien. *Rolling Stone* declared Clark "Best Young Gun" in its April 2011 "Best of Rock" issue. He's acted in films, played at the White House, and has received both Grammy and Blues Music Awards.

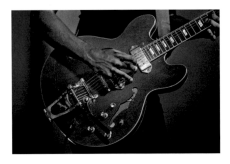

New Orleans Jazz & Heritage Festival, April 2012

LIL' ED WILLIAMS

Ed Williams was taught and mentored on the slide guitar by his uncle, JB Hutto. In the '70s, he formed the Blues Imperials with his half brother James "Pookie" Young and has been going strong ever since. The band has won the Blues Music Award for Band of The Year multiple times. His high-energy shows feature deep Blues, rocking slide guitar, and lots of great good humor.

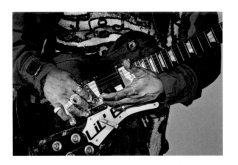

Pennsylvania Blues Festival, Blue Mountain, PA, July 2011

RONNIE EARL

Ronnie is an old and dear friend. He is also one of the most intense guitarists playing today. Ronnie and his band, The Broadcasters, are one of a very few acts that can engage an audience for an all-instrumental three-hour show. He has shared the spotlight with virtually every major Blues artist: B.B. King, Stevie Ray Vaughan, Carlos Santana, Eric Clapton, the Allman Brothers Band, Muddy Waters, Big Joe Turner, Otis Rush, Earl King, Junior Wells, Buddy Guy, Hubert Sumlin, and many more. In addition, he is a

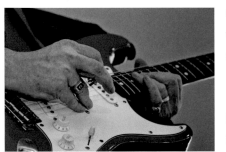

sweet, giving, generous soul who has helped many musicians along in their craft and careers.

Pennsylvania Blues Festival, Blue Mountain, PA, July 2014

SHEMEKIA COPELAND

Ms. Copeland is the daughter of the late Texas Bluesman Johnny Copeland. She began her career by joining her dad on stage as early as age eight. I did Shemekia's first promo pictures for Alligator Records when she was nineteen. We have been friends for a long time. That said, my respect for her went off the charts when she headlined the Bluzapalooza Tour of Iraq and Kuwait, which I documented. Whether there were five or 500 soldiers present, whether she had slept or not, she gave her all and made it personal and special for the troops. She is seen here on a makeshift stage at a military base in Iraq joined by a group of young Marines.

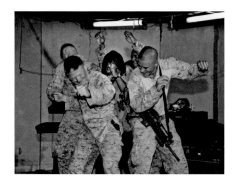

Ramadi, Iraq, 2008

TEENY TUCKER

The daughter of Tommy Tucker, whose hit "High Heel Sneakers" is a Blues and Rock 'n Roll classic, Teeny Tucker has created a strong identity of her own, deeply rooted in Gospel and classic Blues. A standing ovation from the notoriously tough audience at the Apollo

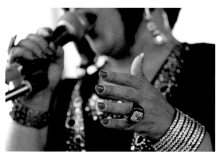

Pennsylvania Blues Festival, Blue Mountain, PA, July 2012

Theater gave her the confidence to embark on her solo career. In addition to performing, Teeny is an educator/lecturer on women in the Blues.

JIMMY LYNCH

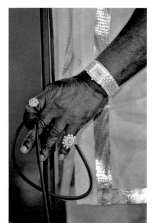

Jimmy is a comedian, singer, dancer, emcee, band leader, and actor often billed as "Mr. Motion" or "The Funky Tramp." He appeared in classic comic films with Rudy Ray Moore, aka Dolemite. He was a Master of Ceremonies on the Legendary R&B Cruise when I took this photo.

Legendary R&B Cruise, January 2007

RORY BLOCK

Aurora "Rory" Block grew up in Manhattan, where her father ran a sandal shop in Greenwich Village in the '60s. The shop was a hangout for Folk and Blues musicians and Ms. Block met and played with artists including Maria Muldaur, John Sebastian, Mississippi John Hurt, Reverend Gary Davis, and Son House. She went on to an award-winning career performing and recording. I love the detail of the inlays on the neck of her guitar.

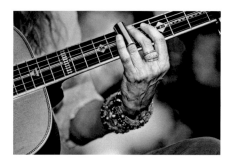

Briggs Farm Blues Festival, Nescopeck, PA, July 2012

RONNIE BAKER BROOKS

Ronnie Baker Brooks is one of the strongest players to come out of Chicago recently. A soulful singer and fiery guitarist, he has his own band and is a member of the Brooks Family Blues Dynasty with his father, Lonnie Brooks, and his brother, Wayne Baker Brooks. I love the inlays of his logo and initials on the neck of his guitar.

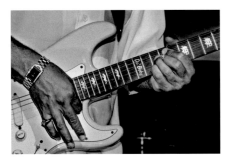

North Atlantic Blues Festival, Rockland, ME, July 2011

SAMANTHA FISH

There is a back story to this picture of young Blues Rocker Samantha Fish, a festival and cruise favorite. On the R&B Cruises there are theme nights and some folks get very involved while others just enjoy the show. The night this photo was taken the theme was "Blue," so Samantha came out in a head-to-toe blue body suit and a blonde wig and jammed for a few numbers. The crowd loved it.

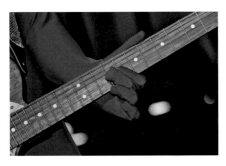

Legendary R&B Cruise, January 2014

NICK SCHNEBELEN

For over ten years Nick was a member of the much-honored sibling group Trampled Under Foot with brother Kris and sister Danielle. He is now on his own with the Slick Nick Schnebelen Band. In 2008, the Kansas City-based musician received the Albert King Award for the most promising guitarist from the Blues Foundation of Memphis, Tennessee.

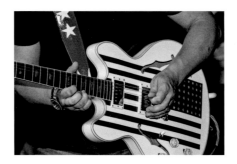

Legendary R&B Cruise, January 2014

JERRY "BOOGIE" MCCAIN

Gadsden, Alabama's Jerry "Boogie" McCain was a real-deal original Bluesman. He recorded prolifically starting in the '50s and continued until he passed in 2012. He wrote the often covered, influential songs "She's Tough" and "Steady," among others. He was also a bounty hunter! He was definitely one of a kind. I always loved his harmonica, his clever lyrics, and his humor.

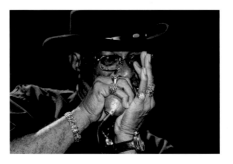

Ponderosa Stomp, New Orleans, LA, April 2009

ALEXIS P. SUTER

Alexis possesses a powerful bass/baritone voice and a commanding presence. Her mother was a noted Gospel singer and Alexis sang in church as a youth. She and the Alexis P. Suter Band were regulars at Levon Helm's legendary Midnight Rambles, opening more than ninety of those shows in Woodstock, NY.

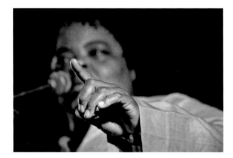

Vermont Blues Festival, Mt. Snow, VT, August 2010

SUSAN TEDESCHI

Susan started her Blues career in New England in the '90s. That led to several recordings and opening for acts all across the Blues/Rock spectrum from B.B. King, Buddy Guy, Taj Mahal, and the Allman Brothers to Bob Dylan and John Mellencamp. She performs with her own band and with her husband, Derek Trucks, in the Grammy Award-winning Tedeschi Trucks Band. A close look at her guitar reveals autographs by B.B. King, John Lee Hooker, Gatemouth Brown, Herbie Hancock, and others.

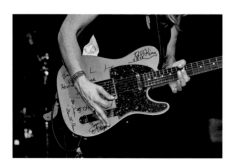

Legendary R&B Cruise, October 2012

DEREK TRUCKS

A prodigy and virtuoso slide guitarist, Derek got his first guitar at nine and played his first professional gig at eleven. At the age of twenty he was leading his own band and was also made an official member of the Allman Brothers Band after several years of guest appearances with them. In 2006, he added a third gig: a stint touring with Eric Clapton. He is the nephew of Butch Trucks, a founding member of the Allman Brothers Band. These days he performs with his own band and with his wife, Susan Tedeschi, in the Tedeschi Trucks Band.

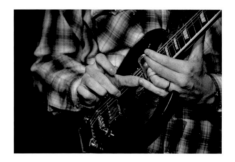

Legendary R&B Cruise, January 2009

MAC ARNOLD

Mac has had an interesting and varied musical career: early experience in a South Carolina band with James Brown on keyboards, a six-year stint as bassist with Muddy Waters' band, and four years in the house band on the TV show "Soul Train," as well as session work. In the '80s, he moved back to South Carolina and eventually formed Mac Arnold and Plate Full

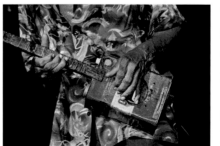

of Blues. He is pictured here playing a homemade gasoline can guitar. He first learned to play guitar on one of these.

Briggs Farm Blues Festival, Nescopeck, PA, July 2013

115

ELVIN BISHOP

Bishop was a founding member of the Paul Butterfield Blues Band, which first exposed many people (including me) to the sound of authentic electric Blues. After leaving Butterfield he formed his own band. The Elvin Bishop Band enjoyed popular success with "Fooled Around and Fell In Love," with Mickey Thompson on vocals. Bishop is known for the goodtime feel of his music and for humorous song writing. He is pictured with "Red Dog," the 1963 Gibson ES-345 given to him by Chicago Blues legend Louis Myers that year. He has played it ever since.

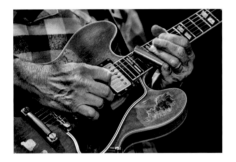

Legendary R&B Cruise, October 2010

EDDIE SHAW

Shaw began his career in Mississippi and then, like so many others, moved to Chicago. There he worked and recorded with Elmore James, Muddy Waters, Otis Rush, Jimmie Reed, Magic Sam, Little Milton, Ike Turner, Freddie King, Willie Dixon, Hound Dog Taylor, and more. He is best known for his work as band leader for the legendary Howlin' Wolf. After Wolf's death in

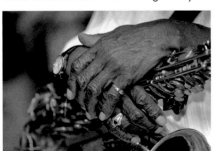

1976, Eddie carried on as Eddie Shaw & the Wolfgang. He was honored in 2014 with induction into the Blues Hall of Fame.

Legendary R&B Cruise, January 2008

JIM RUSSELL

Russell was a true New Orleans original. He was a disc jockey and record and concert promoter who worked with Allen Freed at the dawn of Rock 'n

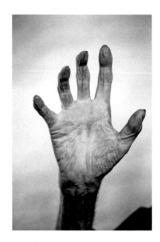

Roll. There is a story that he began staging dances at school gymnasiums, but when the priests and principals fretted over the dancers scuffing the floors Russell said, "OK, we'll make the kids take off their shoes when they dance," thus giving birth to the "sock hop." He also ran Jim Russell's House of Records for over forty years. This photo was at the Ponderosa Stomp conference. He was quite opinionated and emphasized his words by jabbing his hand in the air so I took a picture of his hand.

Ponderosa Stomp,
New Orleans, LA, September 2010

JIMMY MCCRACKLIN

McCracklin had a career that spanned almost seventy years. He made his first records in 1945 and continued to record and perform well into the twenty-first century. A vocalist, pianist, and songwriter, he made consistently great music in the Blues, R&B, Rock 'n Roll, and Soul genres. He was one of the most important artists to come out of the San Francisco Bay area post-World War II. It was seeing this photo and one of bassist Cliff Belcher

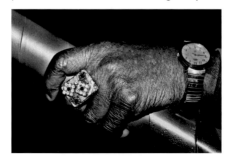

juxtaposed that sparked my *Blues Hands* series.

Legendary R&B Cruise, November 2006

PETE SEEGER

Peter Seeger was the patriarch of American Folk music and a civil rights and environmental activist who was blacklisted in the McCarthy Era. I took this picture at a ninetieth birthday celebration show at the New Orleans Jazz and Heritage Festival, where I got to see the famous inscription on the head of his banjo: "This machine surrounds hate and forces it to surrender."

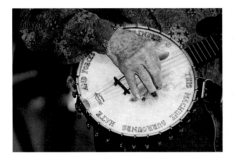

New Orleans Jazz & Heritage Festival, April 2009

TAB BENOIT

Houma, Louisiana's Tab Benoit plays modern Blues-based music in the swampy Louisiana tradition. He is a multiple Blues Music Award winner who tours both with his own trio and the Voice of the Wetlands All Stars. The All Stars feature a cross-section of Louisiana music: Blues, Cajun, Zydeco, Mardis Gras Indian, and more. A passionate advocate, Tab founded the Voice of the Wetlands in 2004 as a volunteer-based non-profit focused on driving awareness about the loss of the wetlands in southern Louisiana. He always plays this vintage Fender Thinline Telecaster.

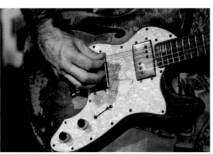

Legendary R&B Cruise, January 2008

RICHARD JOHNSTON

Johnston learned the Mississippi Hill Country Blues by studying with R.L. Burnside, Junior Kimbrough, and Jessie Mae Hemphill. He is best known as a busker, singing and playing on Beale St. in Memphis, Tennessee, and most often playing his "Lowebow" cigar box guitar. This is chronicled in the PBS documentary "Hill Country Troubadour." He won both the Blues Foundation's International Blues Challenge and the Albert King Award for most promising guitarist in 2001.

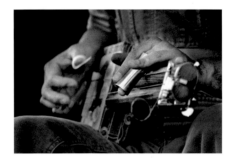

Arkansas Blues & Heritage Festival, Helena, AR, November 2005

IRONING BOARD SAM

Born Sammie Moore in South Carolina, Sam got his stage name when he used a household ironing board to support a leg-less electronic keyboard of his own invention. Sam, who first played Gospel and Boogie Woogie piano, traveled the country as a musician, at one point had a long residency in the clubs on Bourbon Street in New Orleans, and released a string of singles on a variety of labels. In 2010, with the assistance of the Music Makers Relief Foundation, he resumed recording and touring.

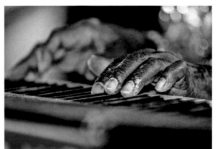

Legendary R&B Cruise, October 2012

CADILLAC JOHN NOLDEN

Nolden is a Mississippi Delta artist who has been performing Blues and Gospel semi-professionally since the '40s. Born in 1927, he continues to perform locally and at festivals, playing in an early Delta style rarely heard today, even in Mississippi.

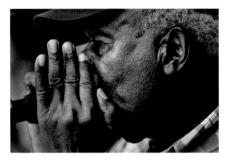

Sunflower River Blues Festival, Clarksdale, MS, August 2006

BIG CHIEF MONK BOUDREAUX

Born Joseph Pierre Boudreaux, Monk is the Big Chief of the Golden Eagles Mardi Gras Indian tribe. In addition to performing on his own and with the

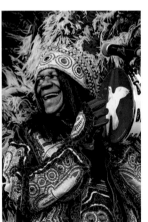

Golden Eagles, he is a member of the Voice of the Wetlands All Stars. The All Stars perform the music of Louisiana and draw attention to the vanishing wetlands and the realities of life in post-Katrina New Orleans. He is pictured here in full Indian costume.

New Orleans Jazz & Heritage Festival, April 2012

BRENT JOHNSON

A former child prodigy, Brent has toured the world with Bryan Lee's Blues Power Band. He was with Lee at the New Orleans Jazz and Heritage Festival when I noticed he had taped a baby picture to his guitar. That's his son Rush. Brent told me he put it on the day Rush was born and it's still there.

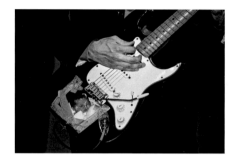

New Orleans Jazz & Heritage Festival, May 2010

ERIC LINDELL

Eric is a singer-songwriter based in New Orleans, but is originally from the San Francisco Bay Area. His career bloomed after he moved to Louisiana in the late '90s. His songs are a mix of Blues, Soul, Funk, and Roots Rock. The "T.C.B." on his fingers stands for Taking Care of Business.

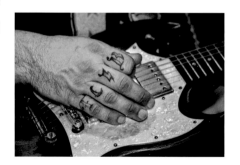

New Orleans Jazz & Heritage Festival, April 2010

MIKE ZITO

Zito is an award-winning Blues-based singer, songwriter, and guitarist who performs with his own band and with the all-star group Royal Southern Brotherhood. The quote on his right arm, "Leave your ego, play the music, love the people," is from the late Blues great Luther Allison.

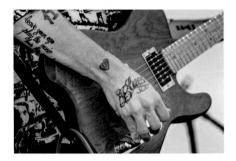

North Atlantic Blues Festival, Rockland, ME, July 2012

MARK WENNER

Mark formed the Nighthawks after graduating from Columbia University in 1972 and returning to his hometown of Washington, DC. Mark and "the

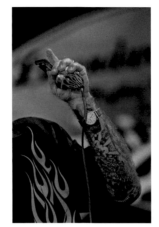

Hawks" have been going strong ever since. He has recorded dozens of albums and performed with virtually every major Blues artist. The Nighthawks were the opening act for Muddy Waters in the show that began my personal Blues adventure.

Legendary R&B Cruise, October 2012

RONNIE JAMES WEBER

Weber is a bassist who has played with a who's who of top modern Blues artists, including Little Charlie and the Nightcats, the Mannish Boys, the

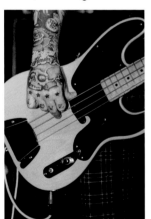

Fabulous Thunderbirds, and James Cotton. This was taken while he was performing with the Fabulous Thunderbirds.

Legendary R&B Cruise, January 2007

EARL SALLEY

Earl is a member of the Zydeco band Chubby Carrier and the Bayou Swamp Band, whose motto is "There ain't no party like a Chubby party." He plays the rubboard, or frottoir (the Creole/Cajun name from the French *frotter*, to rub) and has been known to challenge members of the audience to drink a shot of Tabasco sauce.

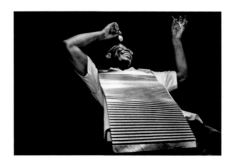

North Atlantic Blues Festival, Rockland, ME, July 2012

SISTA MONICA PARKER

A former Marine, Monica began a successful engineering headhunting firm in Chicago, moved it to California, and added a singing career in 1992. Monica started in the church like so many others before singing Blues and R&B. She possessed a powerful voice and stage presence and toured the world before a recurrence of cancer took her in October 2014.

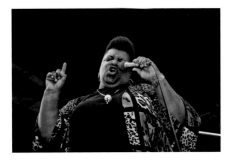

Pennsylvania Blues Festival, Blue Mountain, PA, July 2013

JOSEPH DALEY

Daley is a veteran brass player and educator with a long history in Jazz. He has played with Sam Rivers, Carla Bley, Gil Evans, Charlie Haden, Taj Mahal, and more. He was with Taj Mahal's Tuba Band when I made this photo.

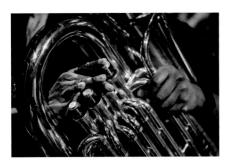

Legendary R&B Cruise, January 2009

BIG JAY MCNEELY

Big Jay had his first hit in 1949 with "The Deacon's Hop." Known for his honking style and wild performances, he often rolled on his back on the stage or took a seat in an audience member's lap, all the while blowing a horn painted fluorescent orange. Though somewhat toned down these days, he is still performing. In 2014, he was inducted into the Blues Hall of Fame.

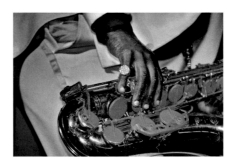

New Orleans Jazz & Heritage Festival, April 2008

RAY NEAL JR.

Ray Neal was born Raful Neal III into the musical Neal Family of Baton Rouge, Louisiana, the third eldest of ten siblings. His father was club owner and musician Raful Neal and his brothers Kenny, Noel, Darnell, and Fredrick are all noted Blues musicians. In addition to his own band, he has toured with James Cotton, Little Milton Campbell, Bobby Rush, and Bobby Bland.

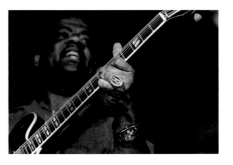

New Orleans Jazz & Heritage Festival, April 2008

COCO ROBICHEAUX

Curtis John Arceneaux adopted the name Coco Robicheaux from a Louisiana legend in which a naughty child is abducted by a werewolf. In addition to

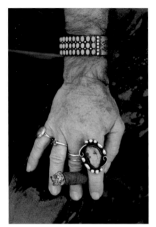

being a musician, storyteller, and visual artist, he appeared in one of the most memorable scenes in the HBO series "Treme," sacrificing a chicken in the studios of WWOZ radio. A genuine New Orleans character, he passed in 2011.

New Orleans Jazz & Heritage Festival, April 2005

KENNY NEAL

Kenny is the keeper of the flame of Baton Rouge Blues. The oldest of ten siblings, he is the son of Raful and brother to Ray, Noel, Darnell, and Fredrick, all Blues musicians. A multi-award winner, he is also an actor, having appeared on Broadway in *Mule Bone*—a play written by Langston Hughes and Zora Neale Hurston in 1930—with new music by Taj Mahal.

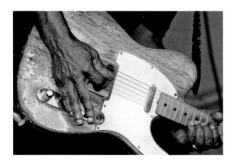

Pocono Blues Festival, Blakeslee, PA, July 2008

DEVON ALLMAN

Devon is the founder of Devon Allman's Honey Tribe and a member of the Blues Rock all-star band Royal Southern Brotherhood. A close look at this photo shows that his Les Paul guitar is autographed by Les Paul himself. Devon's father is Greg Allman, with whom he sometimes shares the stage.

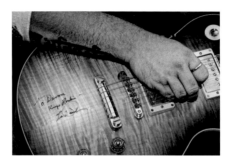

North Atlantic Blues Festival, Rockland, ME, July 2012

CRUSHER CARMEAN

As indicated by the words "BASS" and "SLAP" tattooed on his fingers, "Crusher" plays upright slap-style bass. He is in the Rockabilly, Jump Blues,

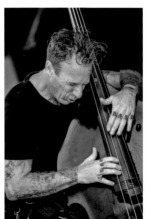

Punk Americana band Gashouse Gorillas. Known for twirling his bass, standing on it, and raising it high above his head, he got his nickname after wrecking many wooden basses. The instrument he now plays (seen here) is made of aluminum.

White Mountain Boogie N' Blues Festival, North Thornton, NH, August 2013

CLIFF BELCHER

Cliff is the bassist in Watermelon Slim and the Workers. A Texan now based in Oklahoma, Cliff has toured and recorded with the best artists in that Blues-rich region. When I saw this image next to one of Jimmy McCracklin's bejeweled hand it was a "light bulb moment" for me and I realized I was going to keep shooting Blues hands.

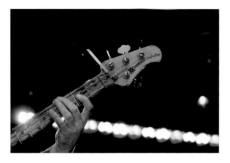

Legendary R&B Cruise, January 2007

CJ CHENIER

CJ's father is Clifton Chenier, the original King of Zydeco, who took the music from Louisiana to the world. CJ carries on that tradition with his powerful Red Hot Louisiana Band—the bluesiest of the current Zydeco bands. His rings represent a king's crown and an accordion.

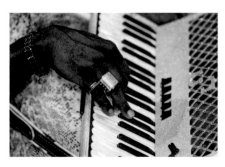

New Orleans Jazz & Heritage Festival, April 2010

CHUCK CAMPBELL

Chuck Campbell is one of four brothers who, as the Campbell Brothers band, play African-American gospel music with electric steel guitar and vocal, often referred to as Sacred Steel. The band uses regular electric, lap steel, and pedal steel guitars.

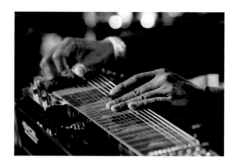

Blast Furnace Blues Festival, Bethlehem, PA, September 2012

ALLEN TOUSSAINT

Allen Toussaint is a New Orleans legend. His work as a performer, composer, and producer created much of the music that has come to be considered classic New Orleans R&B. I remember seeing his gold Rolls-Royce—license plate "PIANO"—parked behind the biggest stage at a New Orleans Jazz & Heritage Festival. He, Dr. John, and the Dalai Lama were awarded honorary doctorates by Tulane University in 2013.

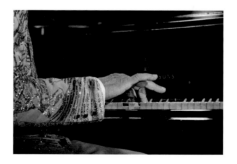

Ponderosa Stomp, New Orleans, LA, October 2011

BOBBY RUSH & MIZZ LOWE

Bobby Rush is a Blues survivor. He is a major player on the southern Soul Blues circuit and has recorded prolifically, scoring national and regional

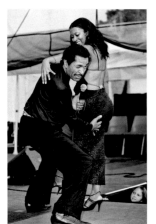

hits. He is also a multiple Blue Music Award winner. His style mixes Blues, Funk, and Soul. His energetic shows usually feature female dancers and good-natured, bawdy humor. I love the little kid in the lower right of this photo.

Pocono Blues Festival,
Blakeslee, PA, July 2008

KENNY "BLUES BOSS" WAYNE

Born in Spokane but raised in New Orleans, Wayne eventually settled in Vancouver. Kenny was a prodigy who started in Gospel and moved on to Boogie Woogie and Blues. He is a winner of both a Juno (Canada's equivalent of the Grammies) and a Living Blues Award.

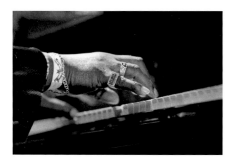

Blast Furnace Blues Festival, Bethlehem, PA, September 2012

PINETOP PERKINS

With a career that started in the '20s and stretched well into the twenty-first century, Joe Willie "Pinetop" Perkins was the Blues. He was one of the last surviving Mississippi Delta Bluesmen. He taught Ike Turner piano. He held down the piano chair in the Muddy Waters band for more than twenty years. After that, he continued his career both as a solo player and with various all-star bands. He became a beloved elder statesman in the Blues community I like to think that this photo—taken when he was ninety-six—reflects a life well spent.

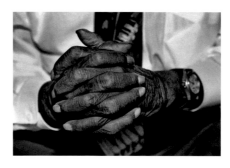

Pocono Blues Festival, Blakeslee, PA, July 2010

LAZY LESTER

Louisianan Leslie Johnson, aka Lazy Lester, was both a featured artist and a session musician on much of the music termed "Swamp Blues" recorded in the '50s and '60s. In addition to his own hits "I'm a Lover Not a Fighter," "I Hear You Knockin'," and "Sugar Coated Love," he played on dozens of records by artists such as Slim Harpo, Lightning Slim, and more. His music

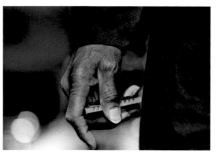

has had a great influence on artists who followed. He was inducted into the Blues Hall of Fame in 2012.

Ponderosa Stomp,
New Orleans, LA, May 2007

SCOT SUTHERLAND

Scot is one of the "first call" bassists on the Blues scene today. He has played with many Blues legends, toured as a member of the Tommy Castro Band for six years, and now plays with high-energy Blues rockers Mike Zito and Samantha Fish.

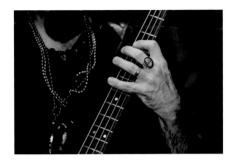

Legendary R&B Cruise, October 2009

MAGIC SLIM

Morris Holt, aka Magic Slim, was a big man with a big, bold sound. He was one of the last remaining links to the first generation of electric Blues artists to come out of Mississippi and migrate north. From the barrooms of Chicago he went on to multiple Handy and Blues Music Awards and worldwide recognition. His playing and singing were always direct, intense, and electrifying. Most people did not realize he had only four fingers on his right hand. He lost a digit to a cotton gin accident in his teens.

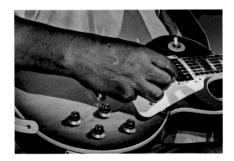

North Atlantic Blues Festival, Rockland, ME, July 2011

ROOSEVELT COLLIER

Collier is a member of the Lee Boys, a group composed of three brothers and three nephews who play the "Sacred Steel" form of Gospel music. He plays pedal steel guitar in the ensemble. Their sound is soaring and propulsive with elements of Blues and Funk, and pretty much always brings audiences to their feet.

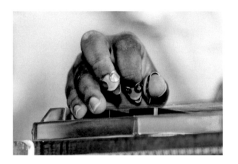

Legendary R&B Cruise, January 2013

BUDDY GUY

Leaving home at a young age, George "Buddy" Guy went from Louisiana to Chicago, where he fell under the spell of Muddy Waters. He, Magic Sam, and Otis Rush defined a more modern form of Chicago Blues. He had a long partnership with harmonica player Junior Wells. His playing has been a major influence on most Blues and Rock players who followed him, including Eric Clapton and Stevie Ray Vaughan. One of the Blues' biggest stars, he has achieved elder statesman status and induction into

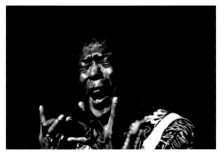

both the Blues Foundation Hall of Fame and the Rock and Roll Hall of Fame.

Benson & Hedges Blues Festival, Beacon Theater, New York, NY 1991

RUTHIE FOSTER

Ruthie is a small woman with a big voice. She went from rural Texas Gospel roots to the music scene in Austin with a stint in the Navy in between. A multiple award-winning artist, she mixes Blues, Gospel, Soul, Folk, and even Reggae into her powerful, heartfelt stage shows.

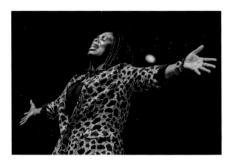

Bradenton Blues Festival, Bradenton, FL, December 2012

MICHAEL BURKS

Michael was an acquaintance who became a good friend during the 2008 Bluzapalooza Tour of Iraq and Kuwait. He was nicknamed "Iron Man" because of his size, power, and endurance, especially when driving the band bus. While his shows featured his own hard-edged Blues sound, he could also play slide, Jazz, or nearly anything he wanted, especially in jam sessions. A big presence and spirit, he was a gentle giant and a really sweet man. Sad to say, he left us suddenly and far too soon in 2012. Rest in peace.

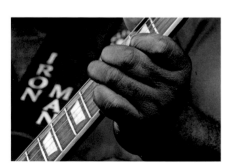

North Atlantic Blues Festival, Rockland, ME July 2011

BIG JAMES MONTGOMERY

Big James got his start in the bands of Albert King and Little Milton and went on to the Chicago Playboys, backing singer Johnny Christian. He has

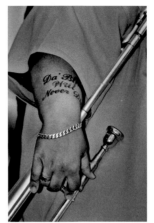

fronted the Playboys as vocalist and trombonist since Christian's passing in 1993. He is seen here with the song title/motto "Da Blues Will Never Die" emblazoned on his forearm

Pocono Blues Festival, Blakeslee, PA, July 2006

BROOKS FAMILY BLUES DYNASTY

The Brooks Family Blues Dynasty is a father and his two sons. Patriarch Lonnie Brooks (center) and sons Wayne Baker Brooks (left) and Ronnie Baker (right) all perform and record as solo artists, with deep history in Louisiana and Chicago Blues. During most Family Dynasty shows they all play each others' instruments for a number or two.

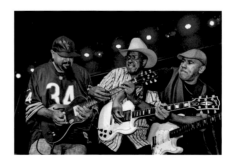

Legendary R&B Cruise, November 2012

LEVON HELM AND HUBERT SUMLIN

Levon Helm gained fame as the drummer/vocalist for the Band. Hubert Sumlin was the guitarist with the legendary Howlin' Wolf for over twenty years. His playing had a vast influence on Blues and Rock players who came after him. Hubert was a cancer survivor; this photo was taken backstage at one of the annual "Howlin' for Hubert" benefits that helped with medical expenses. Hubert's loving and devoted manager, Toni Ann, said about this photo: "I wouldn't know how to put in words the love they (Levon and Hubert) have for each other. Perhaps my dear, talented friend Joseph Rosen can show you through a special moment captured here." I am touched and honored.

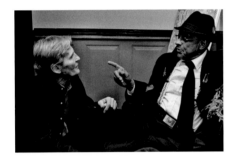

B.B. King's Club, New York, NY, March 2006

THE BLIND BOYS OF ALABAMA

These gentlemen first sang together at the Alabama Institute for the Negro Blind in the late 1930s as the Happyland Jubilee Singers. They became the "Blind Boys" in the '40s, and with a few personnel changes have been harmonizing

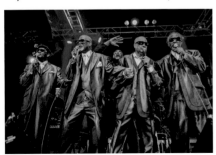

ever since. They are multiple Grammy winners and have recorded with a wide range of artists. Their performances continue to turn out the house and rattle the rafters with genuine Gospel fervor.

Blast Furnace Blues Festival, Bethlehem, PA, February 2014

HONEYBOY EDWARDS

David "Honeyboy" Edwards connected rural Mississippi Delta Blues to the contemporary era. Born in 1915, as a young man he was exposed to the deep Blues of Tommy Johnson and Charlie Patton. He went on to travel and perform with many Delta artists, most notably the legendary Robert Johnson. While still in the South he performed with Muddy Waters, Howlin' Wolf, Big Joe Williams, and Sonny Boy Williamson. And along with them, he migrated north and was present at the inception of modern electric Blues. He was ninety-six when I took this photo and still sharp as a tack, remembering details from a portrait session ten years earlier and catching up on mutual friends. Six months later he passed away.

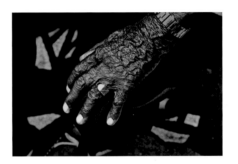

Juke Joint Festival, Clarksdale, MS, April 2011

ACKNOWLEDGMENTS

First, I must thank two old and dear friends: David Aschkenas and Gary Hill. Both were incredibly generous with their time, expertise, and experience. This book would be a weak shadow of what it is without them. David—a fine photographer in his own right—lent his expertise helping to prepare the digital files and scans for the page. Gary brought to bear his talent and deep experience to help make sure the words properly and clearly expressed my thoughts. In addition, I must thank Bob Porter, Dick Waterman, and Bill Wax, who contributed writing to the project and whose contributions to the Blues are beyond measure. I am also grateful to all the good folks at Schiffer Publishing for their commitment to this book. There are so many others whose efforts and support made *Blues Hands* possible, but I must mention Barbara Koppelman, Jill Gewirtz, Jean Meile, Scott Barretta, Marie Walker, Mac Arnold, Debbie Bond, Ayesah King, Steve Berkowitz, and Patricia Morgan.

I must also thank many from the music and photographic worlds. Their inspiration and support have made this book and my photographic life vastly richer. Words cannot express my indebtedness to Herman Leonard and Jenny Bagert and their families; Doc Pomus, Sharyn Felder, and Will Bratton; Mac Rebennack and B.B. St. Roman; Roger Naber, Michael Cloeren, Ira Padnos, and Brad Brewster; Jay Sieleman and Joe Whitmer; Roger Stolle and Jeff Konkel; Erika Stone, Flo Fox, and Sid Kaplan; Howard Christopherson; and Peter Blachley, Aaron Zych, and the management and staff of Morrison Hotel Gallery.

I know I will miss many names that should be included here and I hope I am forgiven for that. I am grateful to all who have supported my efforts.

BIO

Joseph A. Rosen is a freelance photographer based in New York City. His work has appeared in *Time*, *Newsweek*, the *New York Times*, *Sports Illustrated*, and more. In addition to his regular corporate and commercial work, his music clients are among the greatest names in Blues, Jazz, R&B, Soul, Rock, Cajun, and Zydeco, as well as record companies, management groups, and music publications.

© Laura Carbone

Joe began seriously photographing Blues in 1976 with a pilgrimage to see Muddy Waters and has been photographing Blues continuously ever since.

Joe received the prestigious "Keeping the Blues Alive in Photography and Art Award" for 2002. The award is presented by the Blues Foundation to an artist who has created a body of work that has brought the Blues to the public and "made a significant contribution to the Blues world."

In 2006, Joe began a happy and fruitful relationship with the Legendary R&B Cruise, where he leads the photography team and teaches a workshop. In 2008, Joe was selected as the "embedded photojournalist" to document the Bluzapalooza Tour of Iraq and Kuwait. The tour—produced in conjunction with Armed Forces Entertainment and supported by the Blues Foundation and Blues labels and management groups—brought topflight Blues artists to entertain the troops. Also in 2008, Joe became affiliated with the Morrison Hotel Gallery—the premier venue for fine art music photography—where his work is shown with the greats of music photography, both contemporary and historical.